SIMPSONS ™
COMICS
SHAKE-UP

BONGO®
COMICS

SIMPSONS COMICS SHAKE-UP

Collects *Simpsons Comics 105–108 and The Simpsons Summer Shindig 1 & 3*

Copyright © 2014 by
Bongo Entertainment, Inc. All rights reserved.

Bongo Comics Group
P.O. Box 1963, Santa Monica, CA 90406-1963

FIRST EDITION

ISBN 978-1-892849-47-2

14 15 16 17 18 TC 10 9 8 7 6 5 4 3 2 1

Publisher: Matt Groening
Creative Director: Nathan Kane
Managing Editor: Terry Delegeane
Director of Operations: Robert Zaugh
Art Director: Chia-Hsien Jason Ho
Art Director Special Projects: Serban Cristescu
Assistant Art Director: Mike Rote
Production Manager: Christopher Ungar
Assistant Editor: Karen Bates
Production: Nathan Hamill, Art Villanueva
Administration: Ruth Waytz, Pete Benson
Editorial Assistant: Max Davison
Legal Guardian: Susan A. Grode

Printed by TC Transcontinental, Beauceville, QC, Canada. 11/23/13

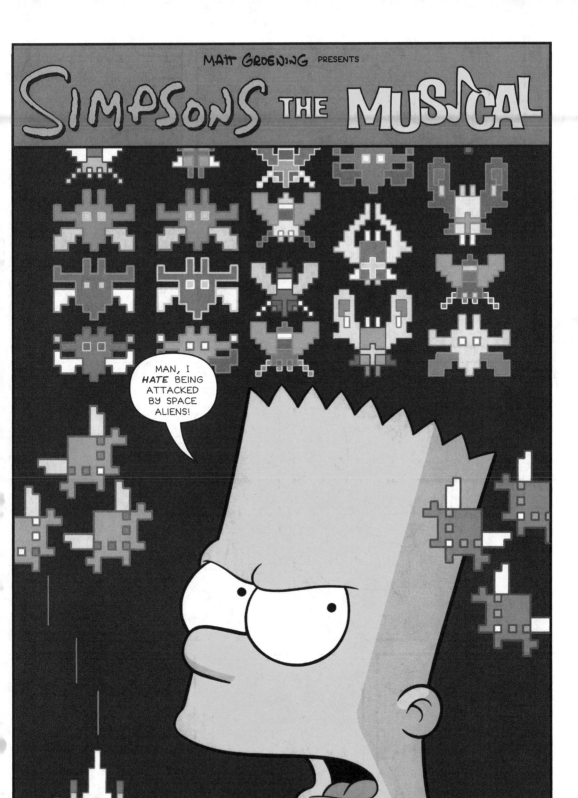

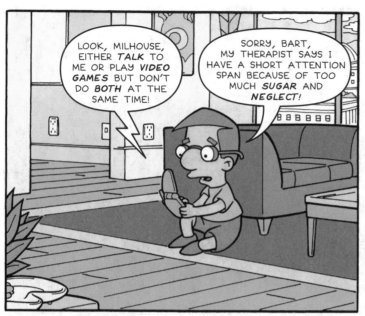

LOOK, MILHOUSE, EITHER *TALK* TO ME OR PLAY *VIDEO GAMES* BUT DON'T DO *BOTH* AT THE SAME TIME!

SORRY, BART, MY THERAPIST SAYS I HAVE A SHORT ATTENTION SPAN BECAUSE OF TOO MUCH *SUGAR* AND *NEGLECT!*

I GOTTA SAY, THESE VIDEO CELL PHONES YOUR MOM'S NEW EXTREME SPORTS BOYFRIEND GOT YOU ARE PRETTY COOL!

YEAH, HE'S TRYING TO BUY MY LOVE!

MAN, YOU'RE *LUCKY!* ALL I GET FROM *MY* PARENTS IS *LOVE* AND *ATTENTION!*

DID YOU SAY SOMETHING, SWEETIE?

:SIGH: SEE?

WELL, I SHOULD BE GOING, SETH IS TAKING ME *BASE-JUMPING* OFF THE TOP OF MOM'S APARTMENT BUILDING.

WHO'S READY FOR SOME *EXTREME BONDING?!!!*

:SIGH!: WHEN ARE YOU COMING BACK TO LIVE WITH YOUR DAD? IT'S NO FUN AROUND HERE WITHOUT YOU!

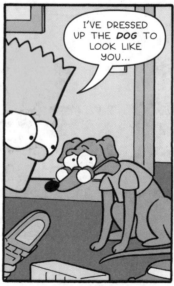

I'VE DRESSED UP THE *DOG* TO LOOK LIKE YOU...

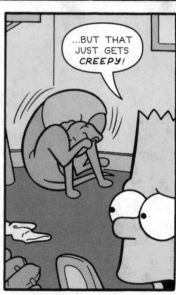

...BUT THAT JUST GETS *CREEPY!*

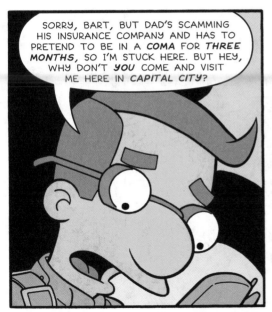

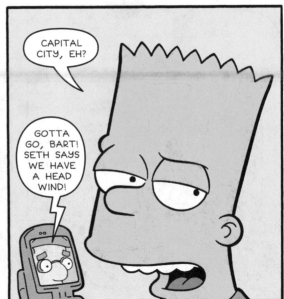

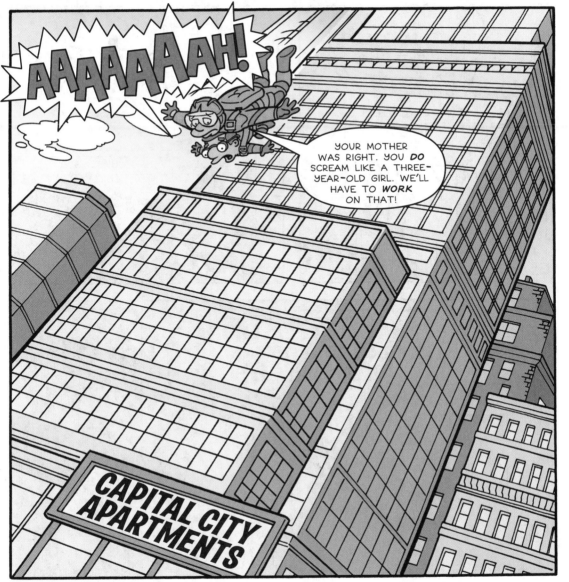

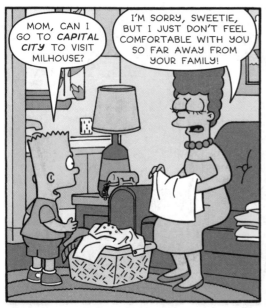

MOM, CAN I GO TO *CAPITAL CITY* TO VISIT MILHOUSE?

I'M SORRY, SWEETIE, BUT I JUST DON'T FEEL COMFORTABLE WITH YOU SO FAR AWAY FROM YOUR FAMILY!

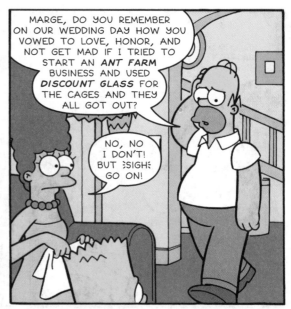

MARGE, DO YOU REMEMBER ON OUR WEDDING DAY HOW YOU VOWED TO LOVE, HONOR, AND NOT GET MAD IF I TRIED TO START AN *ANT FARM* BUSINESS AND USED *DISCOUNT GLASS* FOR THE CAGES AND THEY ALL GOT OUT?

NO, NO I DON'T! BUT ≋SIGH≋ GO ON!

I DON'T KNOW A LOT ABOUT FIRE ANTS, SO I GUESS YOU'D BETTER LET THE EXTERMINATOR I CALLED TELL YOU MORE...

YAAAAH!

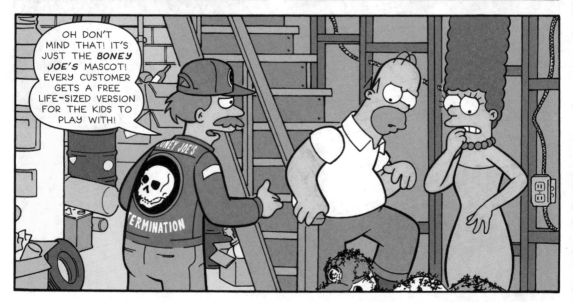

OH DON'T MIND THAT! IT'S JUST THE *BONEY JOE'S* MASCOT! EVERY CUSTOMER GETS A FREE LIFE-SIZED VERSION FOR THE KIDS TO PLAY WITH!

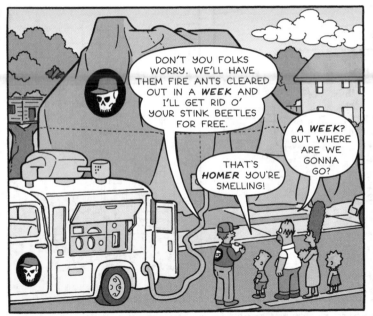

DON'T YOU FOLKS WORRY. WE'LL HAVE THEM FIRE ANTS CLEARED OUT IN A *WEEK* AND I'LL GET RID O' YOUR STINK BEETLES FOR FREE.

A *WEEK*? BUT WHERE ARE WE GONNA GO?

THAT'S *HOMER* YOU'RE SMELLING!

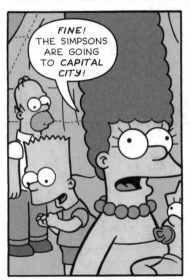

FINE! THE SIMPSONS ARE GOING TO *CAPITAL CITY!*

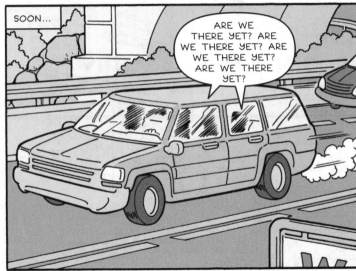

SOON...

ARE WE THERE YET? ARE WE THERE YET? ARE WE THERE YET? ARE WE THERE YET?

NO! NO! *NO!* WHY DO YOU KEEP *ASKING* THAT?!!!

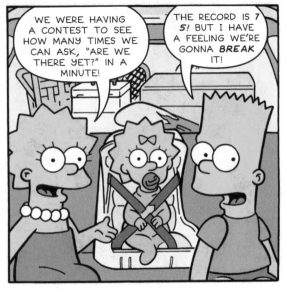

WE WERE HAVING A CONTEST TO SEE HOW MANY TIMES WE CAN ASK, "ARE WE THERE YET?" IN A MINUTE!

THE RECORD IS *7 5!* BUT I HAVE A FEELING WE'RE GONNA *BREAK* IT!

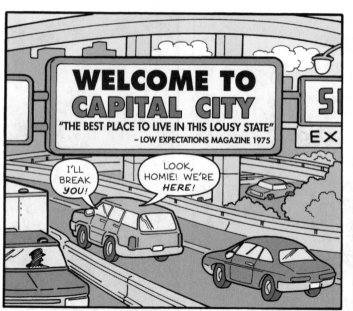

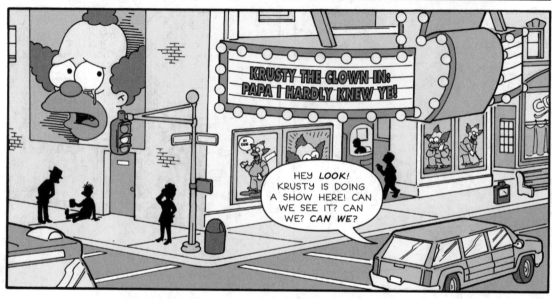

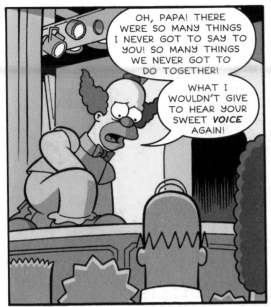

OH, PAPA! THERE WERE SO MANY THINGS I NEVER GOT TO SAY TO YOU! SO MANY THINGS WE NEVER GOT TO DO TOGETHER!

WHAT I WOULDN'T GIVE TO HEAR YOUR SWEET *VOICE* AGAIN!

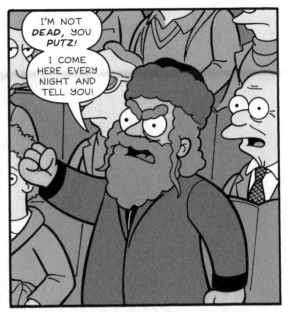

I'M NOT *DEAD*, YOU *PUTZ*!

I COME HERE EVERY NIGHT AND TELL YOU!

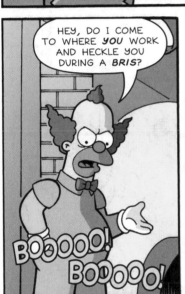

HEY, DO I COME TO WHERE *YOU* WORK AND HECKLE YOU DURING A *BRIS*?

BOOOOO!

BOOOOO!

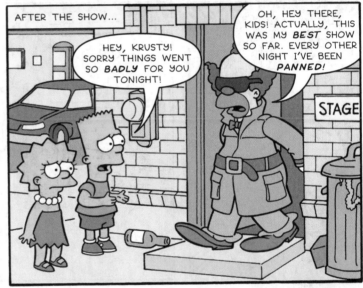

AFTER THE SHOW...

HEY, KRUSTY! SORRY THINGS WENT SO *BADLY* FOR YOU TONIGHT!

OH, HEY THERE, KIDS! ACTUALLY, THIS WAS MY *BEST* SHOW SO FAR. EVERY OTHER NIGHT I'VE BEEN *PANNED*!

STAGE

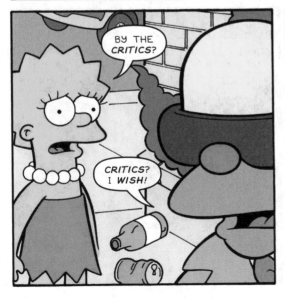

BY THE *CRITICS*?

CRITICS? I *WISH*!

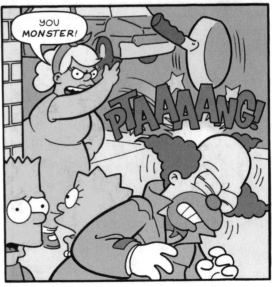

YOU *MONSTER*!

P'TAAAAANG!

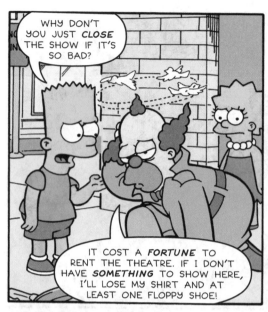

WHY DON'T YOU JUST *CLOSE* THE SHOW IF IT'S SO BAD?

IT COST A *FORTUNE* TO RENT THE THEATRE. IF I DON'T HAVE *SOMETHING* TO SHOW HERE, I'LL LOSE MY SHIRT AND AT LEAST ONE FLOPPY SHOE!

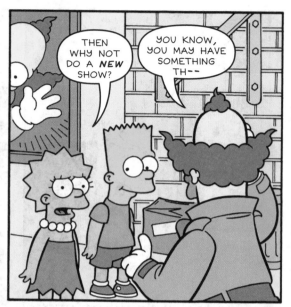

THEN WHY NOT DO A *NEW* SHOW?

YOU KNOW, YOU MAY HAVE SOMETHING TH--

PTAANG!

SICKO!

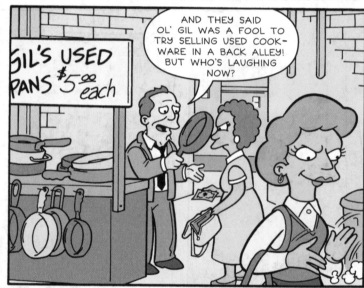

AND THEY SAID OL' GIL WAS A FOOL TO TRY SELLING USED COOK-WARE IN A BACK ALLEY! BUT WHO'S LAUGHING NOW?

GIL'S USED PANS $5.00 each

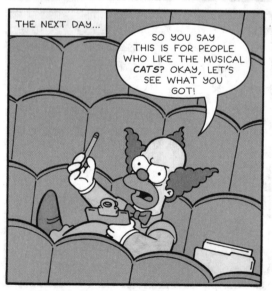

THE NEXT DAY...

SO YOU SAY THIS IS FOR PEOPLE WHO LIKE THE MUSICAL *CATS*? OKAY, LET'S SEE WHAT YOU GOT!

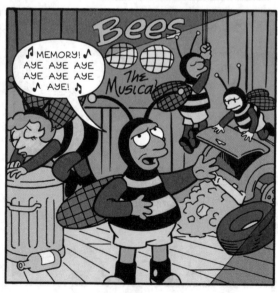

♪ MEMORY! ♪ AYE AYE AYE AYE AYE AYE ♪ AYE! ♪

Bees The Musical

LATER...

HEY THERE! WHAT I'VE GOT FOR YOU IS A *SURE THING*! A LIVE *ITCHY AND SCRATCHY* MUSICAL! I CALL IT *"SINGING THRU THE PAIN!"*

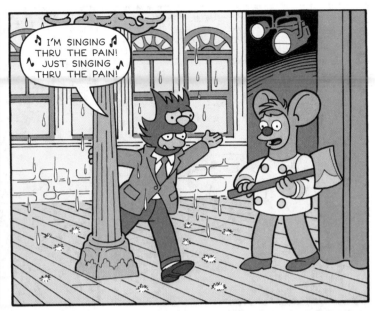

♪ I'M SINGING ♪ ♪ THRU THE PAIN! JUST SINGING ♪ THRU THE PAIN! ♪

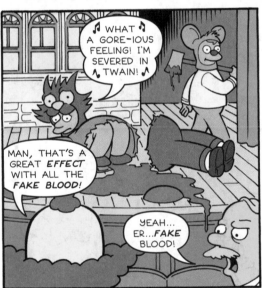

♪ WHAT A GORE-IOUS FEELING! I'M SEVERED IN ♪ TWAIN! ♪

MAN, THAT'S A GREAT *EFFECT* WITH ALL THE *FAKE BLOOD!*

YEAH... ER...*FAKE* BLOOD!

LATER...

MY PLAY HAS ME, RAINIER WOLFCASTLE, ACTION SUPERSTAR, PLAYING FORMER PRESIDENT ABRAHAM LINCOLN, WHO FREES THE THE SLAVES FROM TIME-TRAVELING CONFEDERATE ROBOTS!

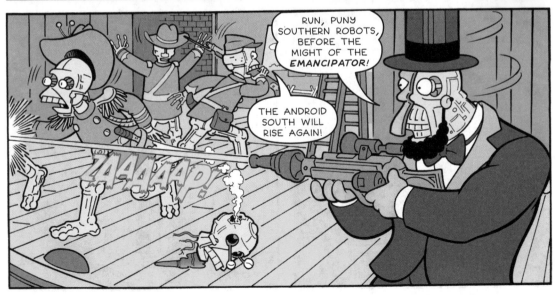

RUN, PUNY SOUTHERN ROBOTS, BEFORE THE MIGHT OF THE *EMANCIPATOR!*

THE ANDROID SOUTH WILL RISE AGAIN!

ZAAAAAP!

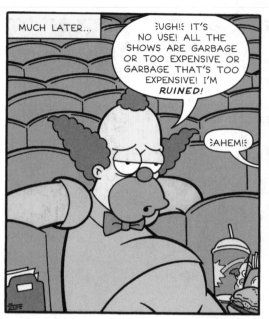

MUCH LATER...

;UGH!; IT'S NO USE! ALL THE SHOWS ARE GARBAGE OR TOO EXPENSIVE OR GARBAGE THAT'S TOO EXPENSIVE! I'M *RUINED!*

;AHEM!;

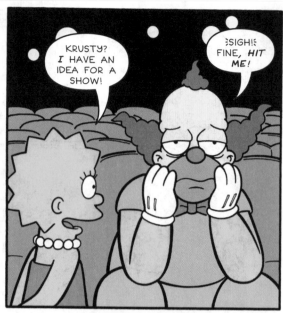

KRUSTY? *I* HAVE AN IDEA FOR A SHOW!

;SIGH!; FINE, *HIT ME!*

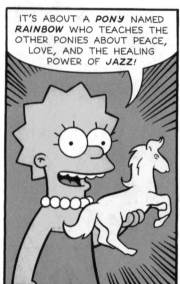

IT'S ABOUT A *PONY* NAMED *RAINBOW* WHO TEACHES THE OTHER PONIES ABOUT PEACE, LOVE, AND THE HEALING POWER OF *JAZZ!*

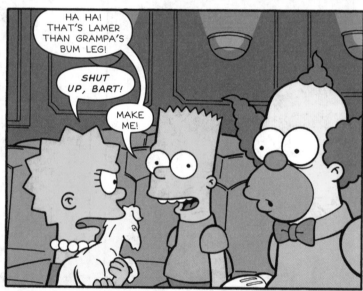

HA HA! THAT'S LAMER THAN GRAMPA'S BUM LEG!

SHUT UP, BART!

MAKE ME!

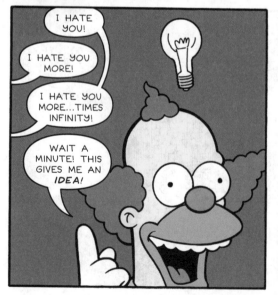

I HATE YOU!

I HATE YOU MORE!

I HATE YOU MORE...TIMES INFINITY!

WAIT A MINUTE! THIS GIVES ME AN *IDEA!*

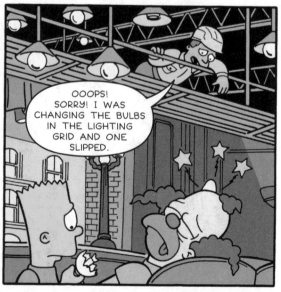

OOOPS! SORRY! I WAS CHANGING THE BULBS IN THE LIGHTING GRID AND ONE SLIPPED.

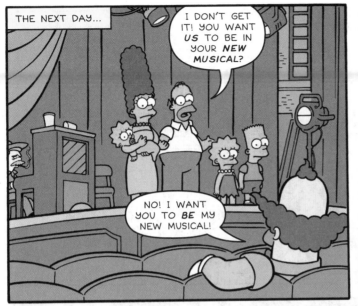

THE NEXT DAY...

I DON'T GET IT! YOU WANT *US* TO BE IN YOUR *NEW MUSICAL*?

NO! I WANT YOU TO *BE* MY NEW MUSICAL!

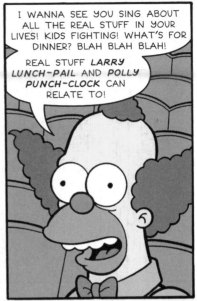

I WANNA SEE YOU SING ABOUT ALL THE REAL STUFF IN YOUR LIVES! KIDS FIGHTING! WHAT'S FOR DINNER? BLAH BLAH BLAH!

REAL STUFF *LARRY LUNCH-PAIL* AND *POLLY PUNCH-CLOCK* CAN RELATE TO!

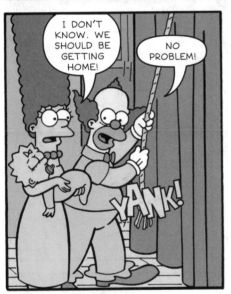

I DON'T KNOW. WE SHOULD BE GETTING HOME!

NO PROBLEM!

YANK!

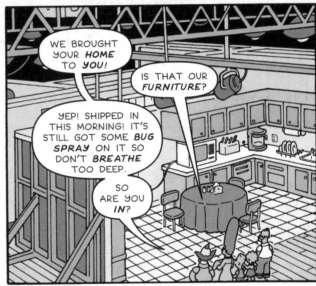

WE BROUGHT YOUR *HOME* TO *YOU*!

IS THAT OUR *FURNITURE*?

YEP! SHIPPED IN THIS MORNING! IT'S STILL GOT SOME *BUG SPRAY* ON IT SO DON'T *BREATHE* TOO DEEP.

SO ARE YOU *IN*?

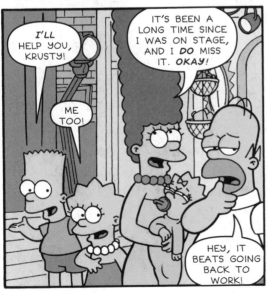

I'LL HELP YOU, KRUSTY!

ME TOO!

IT'S BEEN A LONG TIME SINCE I WAS ON STAGE, AND I *DO* MISS IT. *OKAY*!

HEY, IT BEATS GOING BACK TO WORK!

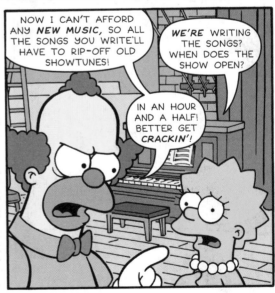

NOW I CAN'T AFFORD ANY *NEW MUSIC*, SO ALL THE SONGS YOU WRITE'LL HAVE TO RIP-OFF OLD SHOWTUNES!

WE'RE WRITING THE SONGS? WHEN DOES THE SHOW OPEN?

IN AN HOUR AND A HALF! BETTER GET *CRACKIN'*!

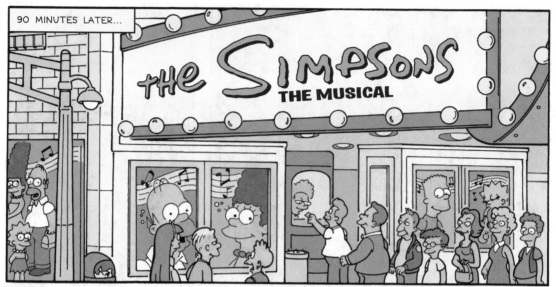

90 MINUTES LATER...

THE SIMPSONS
THE MUSICAL

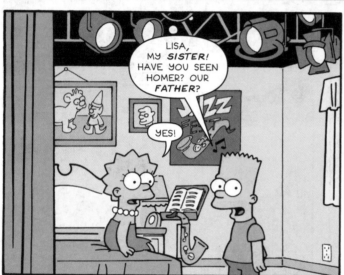

LISA, MY *SISTER!* HAVE YOU SEEN HOMER? OUR *FATHER?*

YES!

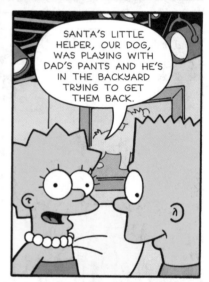

SANTA'S LITTLE HELPER, OUR DOG, WAS PLAYING WITH DAD'S PANTS AND HE'S IN THE BACKYARD TRYING TO GET THEM BACK.

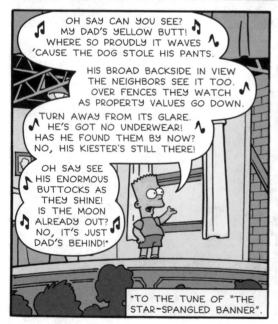

OH SAY CAN YOU SEE? MY DAD'S YELLOW BUTT! WHERE SO PROUDLY IT WAVES 'CAUSE THE DOG STOLE HIS PANTS.

HIS BROAD BACKSIDE IN VIEW THE NEIGHBORS SEE IT TOO. OVER FENCES THEY WATCH AS PROPERTY VALUES GO DOWN.

TURN AWAY FROM ITS GLARE. HE'S GOT NO UNDERWEAR! HAS HE FOUND THEM BY NOW? NO, HIS KIESTER'S STILL THERE!

OH SAY SEE HIS ENORMOUS BUTTOCKS AS THEY SHINE! IS THE MOON ALREADY OUT? NO, IT'S JUST DAD'S BEHIND!*

*TO THE TUNE OF "THE STAR-SPANGLED BANNER".

HA HA! NOW *THAT'S* HOW YOU OPEN A SHOW!

HA! HA! HA! HA! HA! HA! HA! HA! HA! HA!

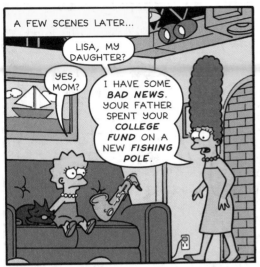

A FEW SCENES LATER...

LISA, MY DAUGHTER?

YES, MOM?

I HAVE SOME *BAD NEWS*. YOUR FATHER SPENT YOUR *COLLEGE FUND* ON A NEW *FISHING POLE*.

:SIGH:

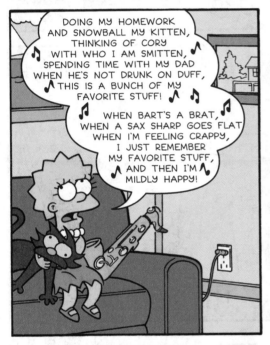

DOING MY HOMEWORK AND SNOWBALL MY KITTEN, THINKING OF CORY WITH WHO I AM SMITTEN, SPENDING TIME WITH MY DAD WHEN HE'S NOT DRUNK ON DUFF, THIS IS A BUNCH OF MY FAVORITE STUFF!

WHEN BART'S A BRAT, WHEN A SAX SHARP GOES FLAT WHEN I'M FEELING CRAPPY, I JUST REMEMBER MY FAVORITE STUFF, AND THEN I'M MILDLY HAPPY!

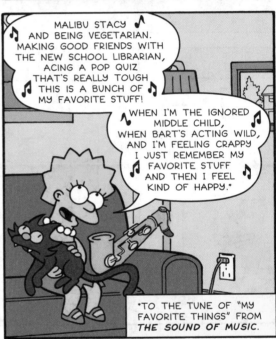

MALIBU STACY AND BEING VEGETARIAN. MAKING GOOD FRIENDS WITH THE NEW SCHOOL LIBRARIAN, ACING A POP QUIZ THAT'S REALLY TOUGH THIS IS A BUNCH OF MY FAVORITE STUFF!

WHEN I'M THE IGNORED MIDDLE CHILD, WHEN BART'S ACTING WILD, AND I'M FEELING CRAPPY I JUST REMEMBER MY FAVORITE STUFF AND THEN I FEEL KIND OF HAPPY.*

*TO THE TUNE OF "MY FAVORITE THINGS" FROM *THE SOUND OF MUSIC*.

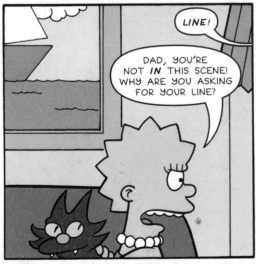

LINE!

DAD, YOU'RE NOT *IN* THIS SCENE! WHY ARE YOU ASKING FOR YOUR LINE?

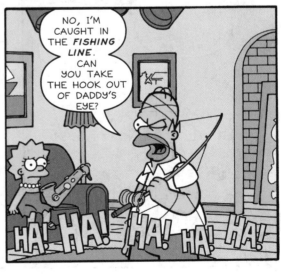

NO, I'M CAUGHT IN THE *FISHING LINE*. CAN YOU TAKE THE HOOK OUT OF DADDY'S EYE?

HA! HA! HA! HA! HA!

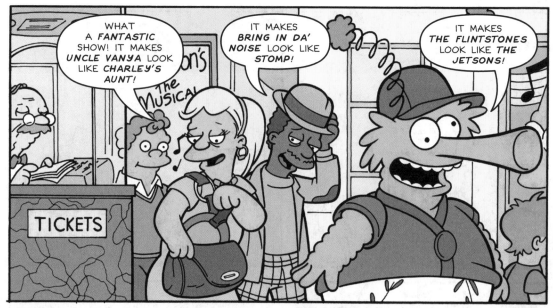

WHAT A **FANTASTIC** SHOW! IT MAKES **UNCLE VANYA** LOOK LIKE **CHARLEY'S AUNT!**

IT MAKES **BRING IN DA' NOISE** LOOK LIKE **STOMP!**

IT MAKES **THE FLINTSTONES** LOOK LIKE **THE JETSONS!**

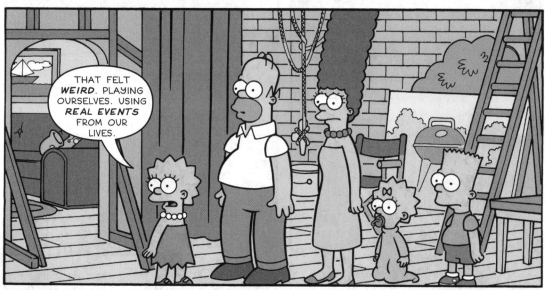

THAT FELT **WEIRD.** PLAYING OURSELVES. USING **REAL EVENTS** FROM OUR LIVES.

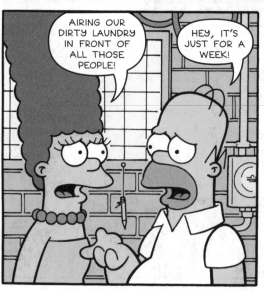

AIRING OUR DIRTY LAUNDRY IN FRONT OF ALL THOSE PEOPLE!

HEY, IT'S JUST FOR A WEEK!

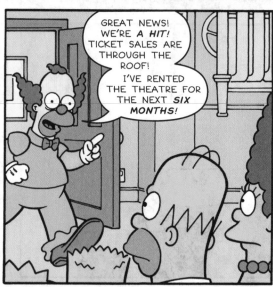

GREAT NEWS! WE'RE **A HIT!** TICKET SALES ARE THROUGH THE ROOF!

I'VE RENTED THE THEATRE FOR THE NEXT **SIX MONTHS!**

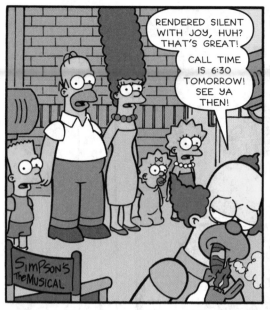

RENDERED SILENT WITH JOY, HUH? THAT'S GREAT!

CALL TIME IS 6:30 TOMORROW! SEE YA THEN!

SIMPSON'S The MUSICAL

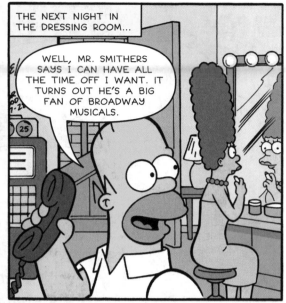

THE NEXT NIGHT IN THE DRESSING ROOM...

WELL, MR. SMITHERS SAYS I CAN HAVE ALL THE TIME OFF I WANT. IT TURNS OUT HE'S A BIG FAN OF BROADWAY MUSICALS.

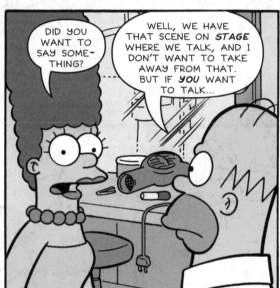

DID YOU WANT TO SAY SOMETHING?

WELL, WE HAVE THAT SCENE ON *STAGE* WHERE WE TALK, AND I DON'T WANT TO TAKE AWAY FROM THAT. BUT IF *YOU* WANT TO TALK...

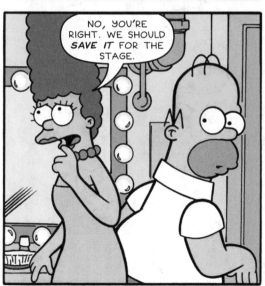

NO, YOU'RE RIGHT. WE SHOULD *SAVE IT* FOR THE STAGE.

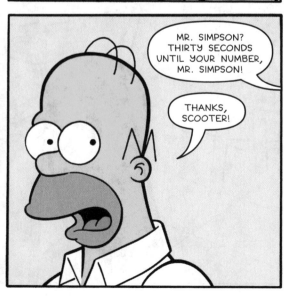

MR. SIMPSON? THIRTY SECONDS UNTIL YOUR NUMBER, MR. SIMPSON!

THANKS, SCOOTER!

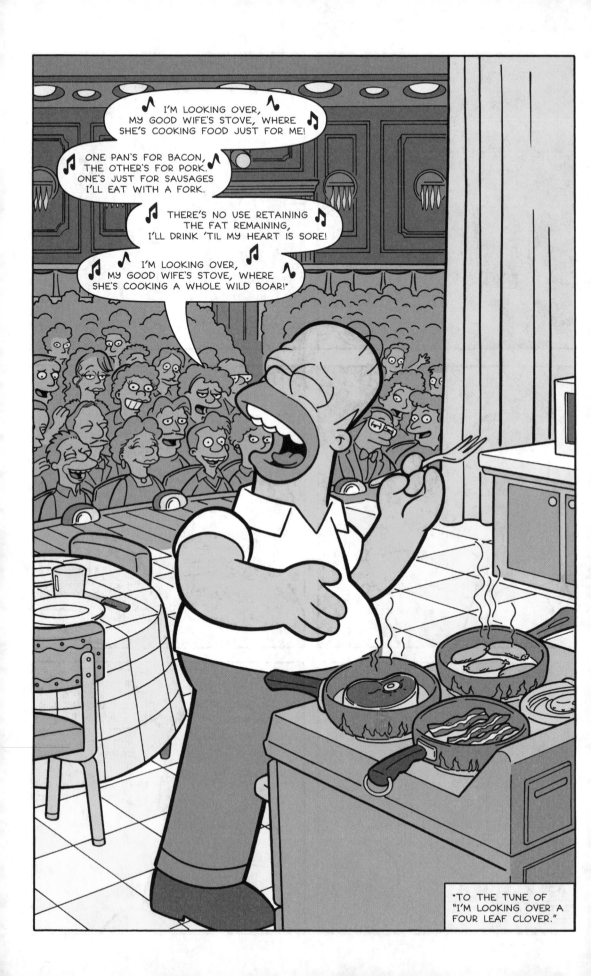

LATER...

YOU'RE AN ANNOYING *JERK!*

NO, *YOU* ARE!

NO, YOU ARE!

NO, *YOU* ARE!

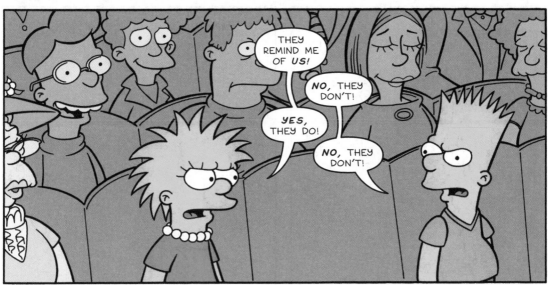

THEY REMIND ME OF *US!*

NO, THEY DON'T!

YES, THEY DO!

NO, THEY DON'T!

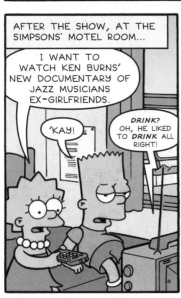

AFTER THE SHOW, AT THE SIMPSONS' MOTEL ROOM...

I WANT TO WATCH KEN BURNS' NEW DOCUMENTARY OF JAZZ MUSICIANS EX-GIRLFRIENDS.

'KAY!

DRINK? OH, HE LIKED TO *DRINK* ALL RIGHT!

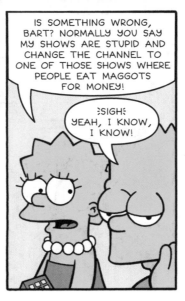

IS SOMETHING WRONG, BART? NORMALLY YOU SAY MY SHOWS ARE STUPID AND CHANGE THE CHANNEL TO ONE OF THOSE SHOWS WHERE PEOPLE EAT MAGGOTS FOR MONEY!

:SIGH: YEAH, I KNOW, I KNOW!

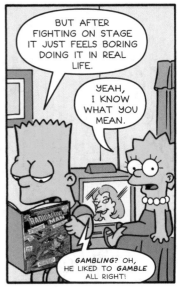

BUT AFTER FIGHTING ON STAGE IT JUST FEELS BORING DOING IT IN REAL LIFE.

YEAH, I KNOW WHAT YOU MEAN.

GAMBLING? OH, HE LIKED TO *GAMBLE* ALL RIGHT!

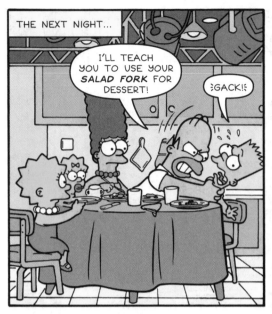

THE NEXT NIGHT...

I'LL TEACH YOU TO USE YOUR *SALAD FORK* FOR DESSERT!

;GACK!;

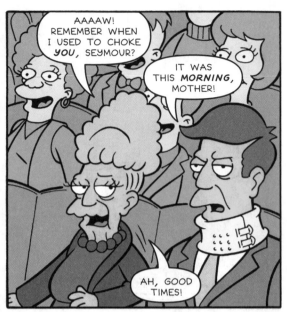

AAAAW! REMEMBER WHEN I USED TO CHOKE *YOU*, SEYMOUR?

IT WAS THIS *MORNING*, MOTHER!

AH, GOOD TIMES!

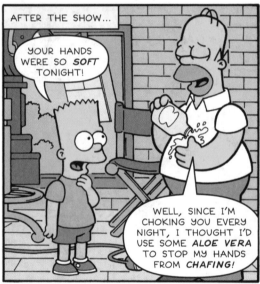

AFTER THE SHOW...

YOUR HANDS WERE SO *SOFT* TONIGHT!

WELL, SINCE I'M CHOKING YOU EVERY NIGHT, I THOUGHT I'D USE SOME *ALOE VERA* TO STOP MY HANDS FROM *CHAFING!*

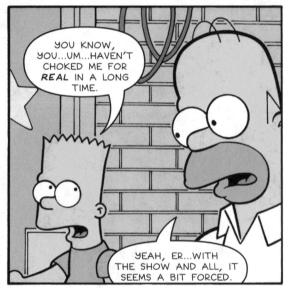

YOU KNOW, YOU...UM...HAVEN'T CHOKED ME FOR *REAL* IN A LONG TIME.

YEAH, ER...WITH THE SHOW AND ALL, IT SEEMS A BIT FORCED.

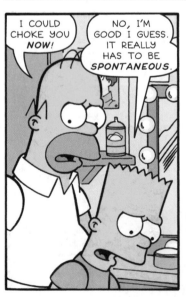

I COULD CHOKE YOU *NOW!*

NO, I'M GOOD I GUESS. IT REALLY HAS TO BE *SPONTANEOUS.*

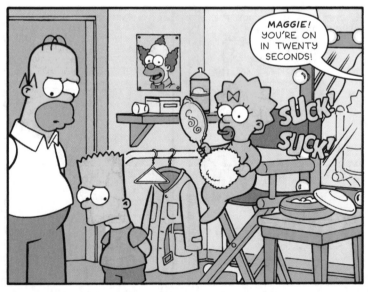

MAGGIE! YOU'RE ON IN TWENTY SECONDS!

SUCK! SUCK!

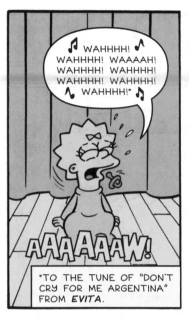

♪ "WAHHHH! ♪ WAHHHH! WAAAAH! WAHHHH! WAHHHH! WAHHHH! WAHHHH! ♪ WAHHHH!" ♪

AAAAAAW!

*TO THE TUNE OF "DON'T CRY FOR ME ARGENTINA" FROM *EVITA*.

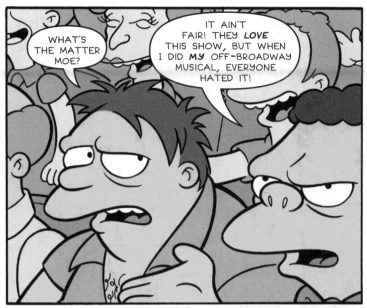

WHAT'S THE MATTER MOE?

IT AIN'T FAIR! THEY *LOVE* THIS SHOW, BUT WHEN I DID *MY* OFF-BROADWAY MUSICAL, EVERYONE HATED IT!

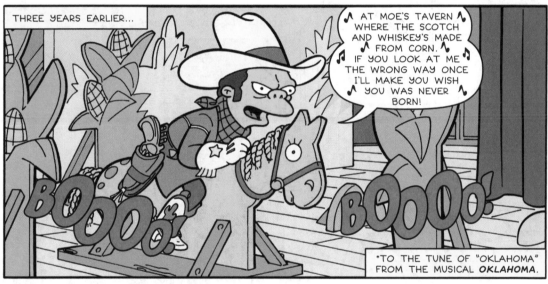

THREE YEARS EARLIER...

♪ AT MOE'S TAVERN ♪ WHERE THE SCOTCH AND WHISKEY'S MADE FROM CORN. ♪ IF YOU LOOK AT ME THE WRONG WAY ONCE I'LL MAKE YOU WISH ♪ YOU WAS NEVER BORN!

*TO THE TUNE OF "OKLAHOMA" FROM THE MUSICAL *OKLAHOMA*.

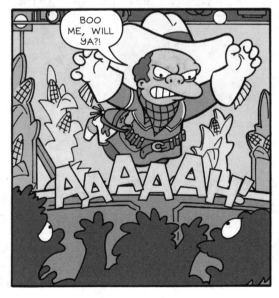

BOO ME, WILL YA?!

AAAAAAH!

WHY DON'T YOU TRY AGAIN, MOE?

NAH, I CUT UP THAT *NEW YORK TIMES* CRITIC PRETTY BAD. THERE'S NO GOIN' BACK.

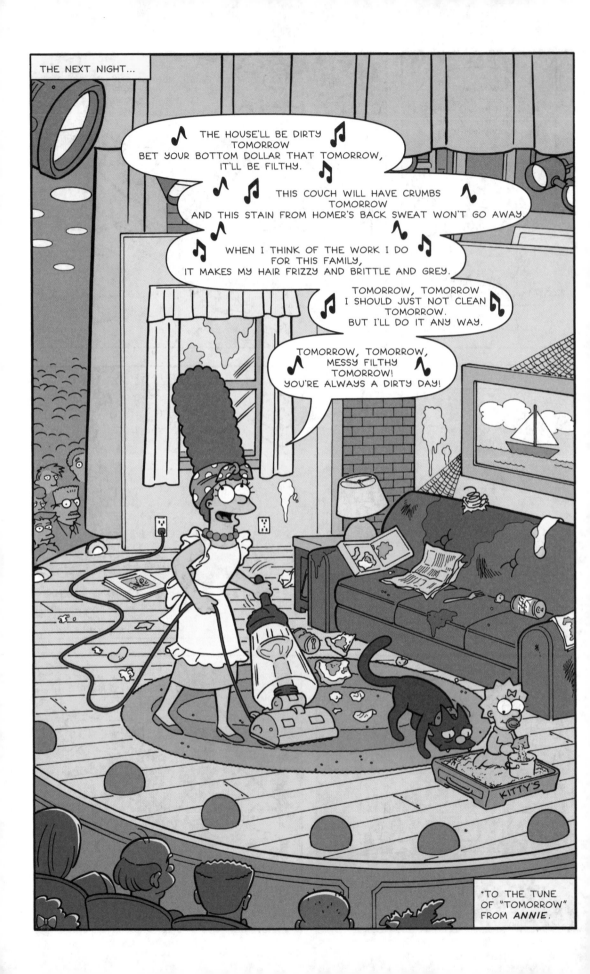

AFTER THE SHOW...

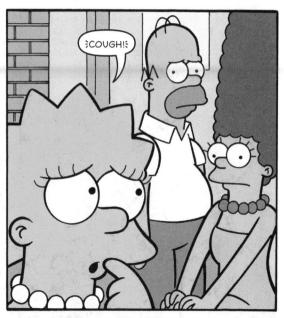

¦COUGH!¦

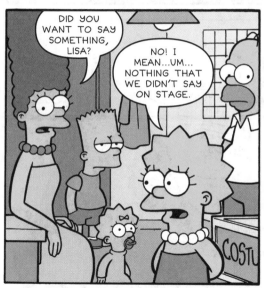

DID YOU WANT TO SAY SOMETHING, LISA?

NO! I MEAN...UM... NOTHING THAT WE DIDN'T SAY ON STAGE.

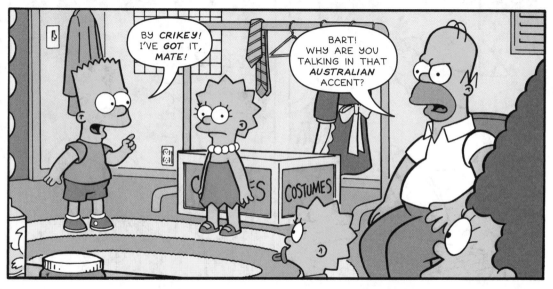

BY *CRIKEY!* I'VE *GOT* IT, *MATE!*

BART! WHY ARE YOU TALKING IN THAT *AUSTRALIAN* ACCENT?

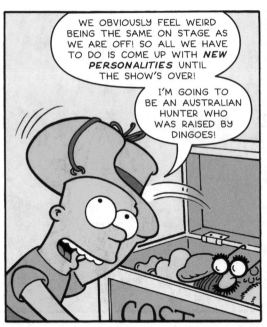

WE OBVIOUSLY FEEL WEIRD BEING THE SAME ON STAGE AS WE ARE OFF! SO ALL WE HAVE TO DO IS COME UP WITH *NEW PERSONALITIES* UNTIL THE SHOW'S OVER!

I'M GOING TO BE AN AUSTRALIAN HUNTER WHO WAS RAISED BY DINGOES!

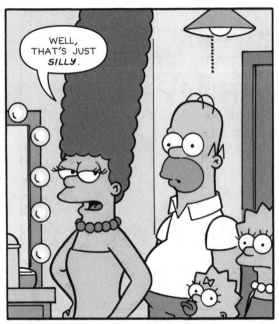

WELL, THAT'S JUST *SILLY*.

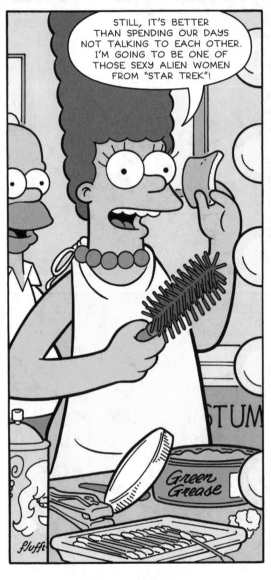

STILL, IT'S BETTER THAN SPENDING OUR DAYS NOT TALKING TO EACH OTHER. I'M GOING TO BE ONE OF THOSE SEXY ALIEN WOMEN FROM "STAR TREK"!

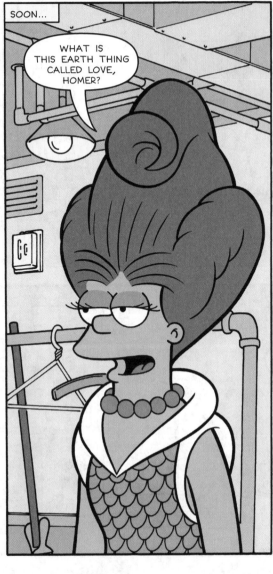

SOON...

WHAT IS THIS EARTH THING CALLED LOVE, HOMER?

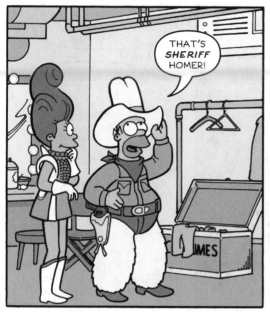

THAT'S *SHERIFF* HOMER!

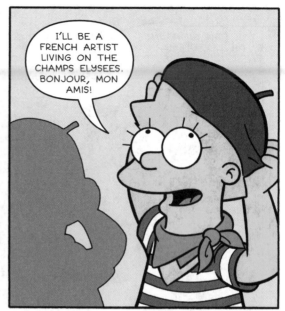

I'LL BE A FRENCH ARTIST LIVING ON THE CHAMPS ELYSEES. BONJOUR, MON AMIS!

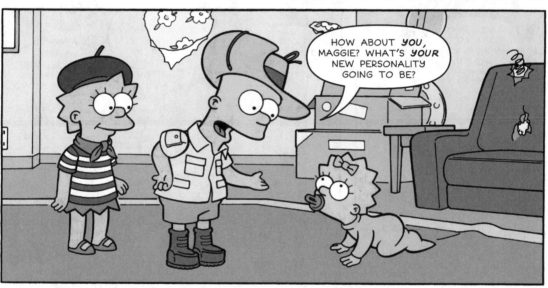

HOW ABOUT *YOU*, MAGGIE? WHAT'S *YOUR* NEW PERSONALITY GOING TO BE?

:BARK!:

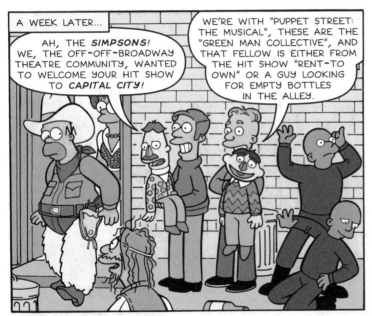

A WEEK LATER...

AH, THE *SIMPSONS*! WE, THE OFF-OFF-BROADWAY THEATRE COMMUNITY, WANTED TO WELCOME YOUR HIT SHOW TO *CAPITAL CITY*!

WE'RE WITH "PUPPET STREET: THE MUSICAL", THESE ARE THE "GREEN MAN COLLECTIVE", AND THAT FELLOW IS EITHER FROM THE HIT SHOW "RENT-TO OWN" OR A GUY LOOKING FOR EMPTY BOTTLES IN THE ALLEY.

WELL I RECKON THAT'S MIGHTY NEIGHBORLY OF YA', PARDNERS!

PTJJJJUJi

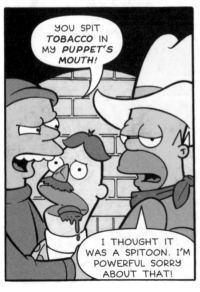

YOU SPIT *TOBACCO* IN MY *PUPPET'S MOUTH!*

I THOUGHT IT WAS A SPITOON. I'M POWERFUL SORRY ABOUT THAT!

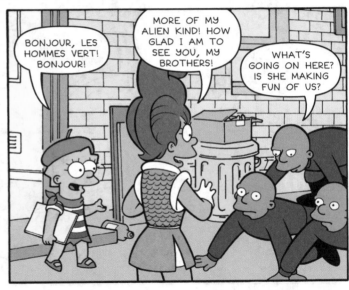

BONJOUR, LES HOMMES VERT! BONJOUR!

MORE OF MY ALIEN KIND! HOW GLAD I AM TO SEE YOU, MY BROTHERS!

WHAT'S GOING ON HERE? IS SHE MAKING FUN OF US?

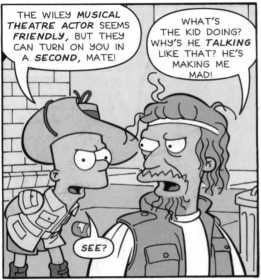

THE WILEY *MUSICAL THEATRE ACTOR* SEEMS *FRIENDLY,* BUT THEY CAN TURN ON YOU IN A *SECOND,* MATE!

WHAT'S THE KID DOING? WHY'S HE *TALKING* LIKE THAT? HE'S MAKING ME MAD!

SEE?

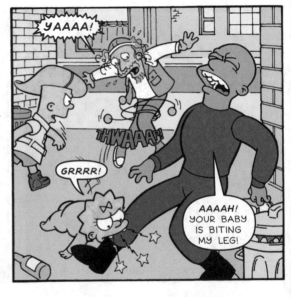

YAAAA!

THWAAAP!

GRRRR!

AAAAH! YOUR BABY IS BITING MY LEG!

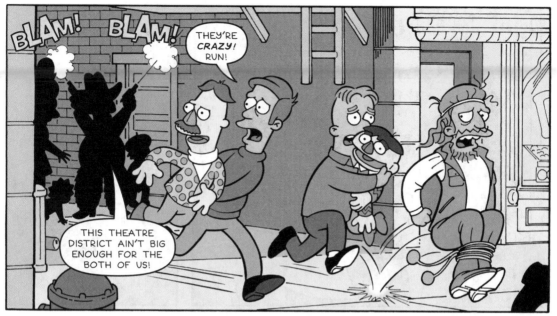

BLAM! BLAM!

THEY'RE *CRAZY*! RUN!

THIS THEATRE DISTRICT AIN'T BIG ENOUGH FOR THE BOTH OF US!

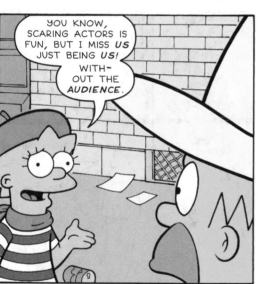

YOU KNOW, SCARING ACTORS IS FUN, BUT I MISS *US* JUST BEING *US*! WITHOUT THE *AUDIENCE*.

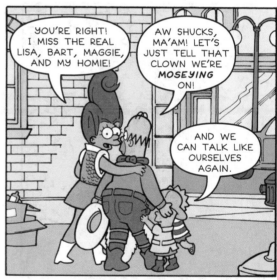

YOU'RE RIGHT! I MISS THE REAL LISA, BART, MAGGIE, AND MY HOMIE!

AW SHUCKS, MA'AM! LET'S JUST TELL THAT CLOWN WE'RE *MOSEYING* ON!

AND WE CAN TALK LIKE OURSELVES AGAIN.

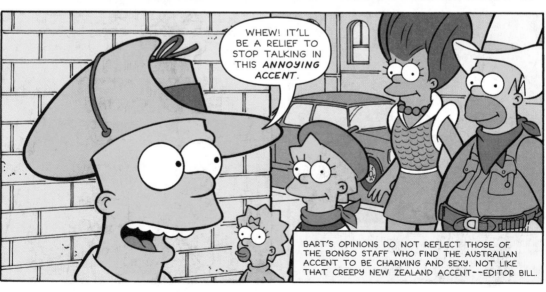

WHEW! IT'LL BE A RELIEF TO STOP TALKING IN THIS *ANNOYING ACCENT*.

BART'S OPINIONS DO NOT REFLECT THOSE OF THE BONGO STAFF WHO FIND THE AUSTRALIAN ACCENT TO BE CHARMING AND SEXY. NOT LIKE THAT CREEPY NEW ZEALAND ACCENT--EDITOR BILL.

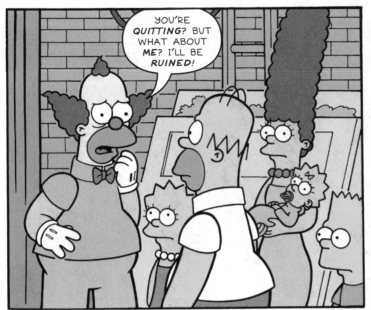

YOU'RE *QUITTING*? BUT WHAT ABOUT *ME*? I'LL BE *RUINED*!

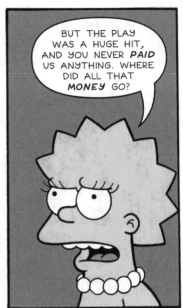

BUT THE PLAY WAS A HUGE HIT, AND YOU NEVER *PAID* US ANYTHING. WHERE DID ALL THAT *MONEY* GO?

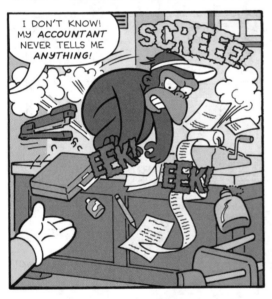

I DON'T KNOW! MY *ACCOUNTANT* NEVER TELLS ME *ANYTHING*!

SCREEE!

EEK!

EEK!

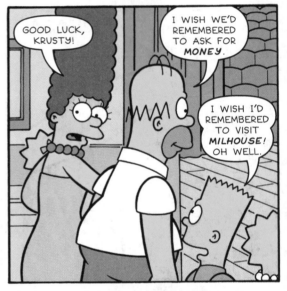

GOOD LUCK, KRUSTY!

I WISH WE'D REMEMBERED TO ASK FOR *MONEY*.

I WISH I'D REMEMBERED TO VISIT *MILHOUSE*! OH WELL.

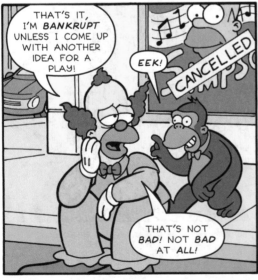

THAT'S IT, I'M *BANKRUPT* UNLESS I COME UP WITH ANOTHER IDEA FOR A PLAY!

EEK!

CANCELLED

THAT'S NOT *BAD*! NOT BAD AT *ALL*!

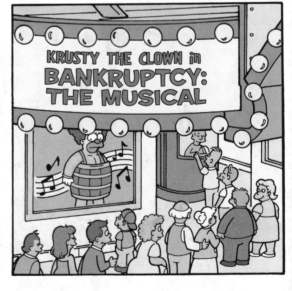

KRUSTY THE CLOWN in BANKRUPTCY: THE MUSICAL

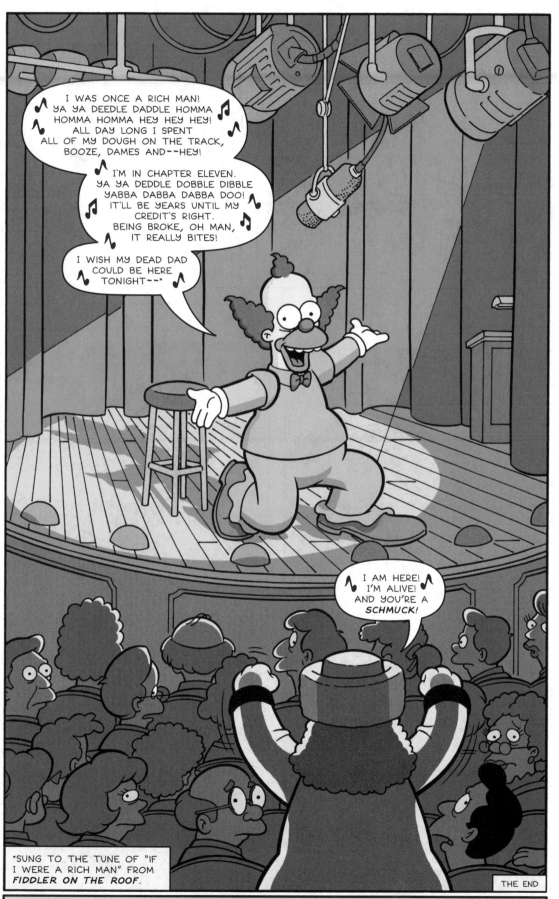

*"SUNG TO THE TUNE OF "IF I WERE A RICH MAN" FROM *FIDDLER ON THE ROOF.*

THE END

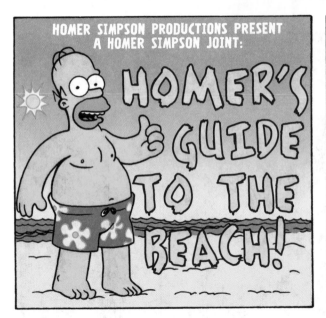

HOMER SIMPSON PRODUCTIONS PRESENT A HOMER SIMPSON JOINT:

HOMER'S GUIDE TO THE BEACH!

THERE'S ONLY ONE PROBLEM WITH TAKING YOUR FAMILY TO THE BEACH...YOUR FAMILY HAS TO COME ALONG.

WHEN YOU GET TO THE BEACH, YOU NEED TO PICK A GOOD SPOT FAST BEFORE THEY'RE ALL GONE.

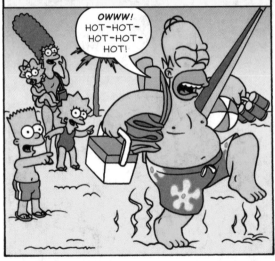

OWWW! HOT-HOT-HOT-HOT-HOT!

REMEMBER, WE SHARE THE BEACH WITH NATURE, SO IT'S OUR JOB TO KEEP THE BEACH CLEAN...

BUT NATURE SHOULD DO *ITS* PART, TOO.

LAZY NATURE!

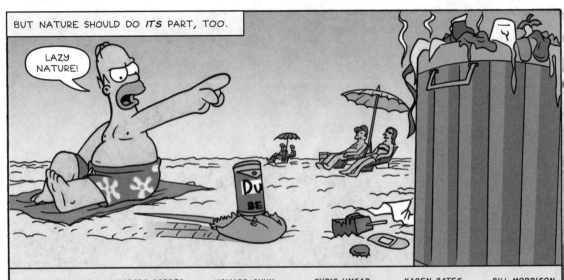

TONY DIGEROLAMO
SCRIPT

MARCOS ASPREC
PENCILS

HOWARD SHUM
INKS

CHRIS UNGAR
COLORS

KAREN BATES
LETTERS

BILL MORRISON
EDITOR

MAKING A SAND CASTLE IS HARD, BUT MAKING A TRASH CASTLE IS EASY AND SAVES YOU A TRIP TO THE TRASHCAN.

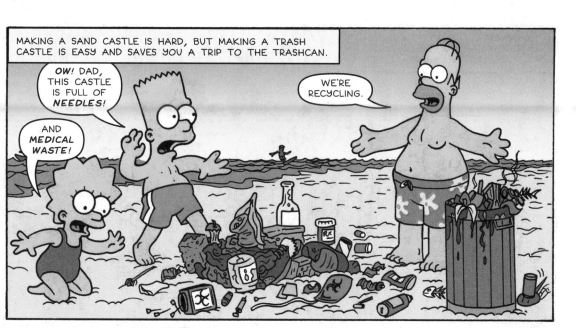

OW! DAD, THIS CASTLE IS FULL OF *NEEDLES*!

AND *MEDICAL WASTE*!

WE'RE RECYCLING.

PEOPLE SAY, THAT TANNING IS UNSAFE AND THAT IT MAY CAUSE MELON AMMONIA.

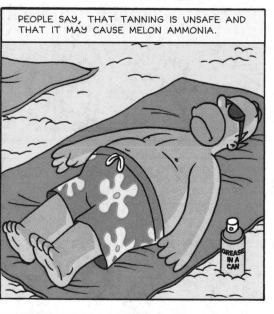

GREASE IN A CAN

THOSE PEOPLE ARE PALE DORKS. DON'T LISTEN TO THEM.

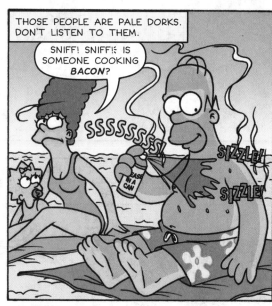

SNIFF! SNIFF!: IS SOMEONE COOKING *BACON*?

SSSSSSSS!

SIZZLE!

SIZZLE!

GREASE IN A CAN

REMEMBER, IF YOU GET TIRED OF SWIMMING, JUST CALL A LIFEGUARD. THEY *HAVE* TO PULL YOU OUT. IT'S THEIR JOB.

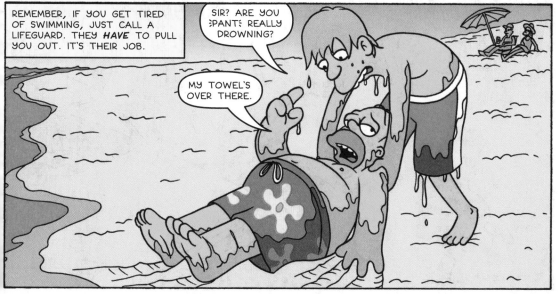

SIR? ARE YOU ЗPANTΞ REALLY DROWNING?

MY TOWEL'S OVER THERE.

THE BEACH IS A GREAT PLACE TO REKINDLE ROMANCE AND LET YOUR KIDS RUN WILD.

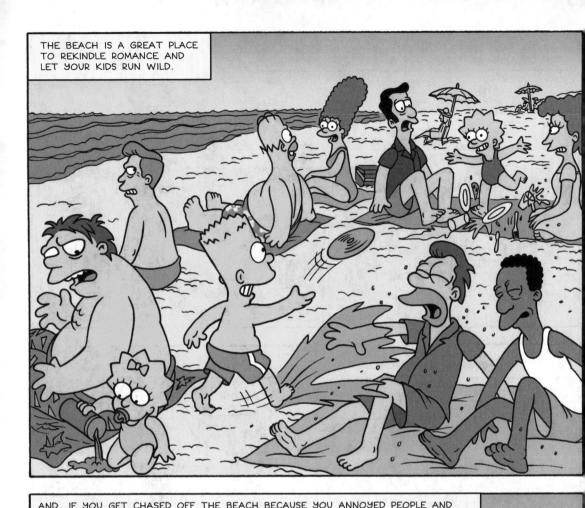

AND, IF YOU GET CHASED OFF THE BEACH BECAUSE YOU ANNOYED PEOPLE AND BROKE SOME LAWS, DON'T WORRY. THERE ARE *THOUSANDS OF MILES* OF OTHER BEACHES IN THE UNITED STATES WHERE NOBODY'S EVER *HEARD* OF YOU! HEH-HEH!

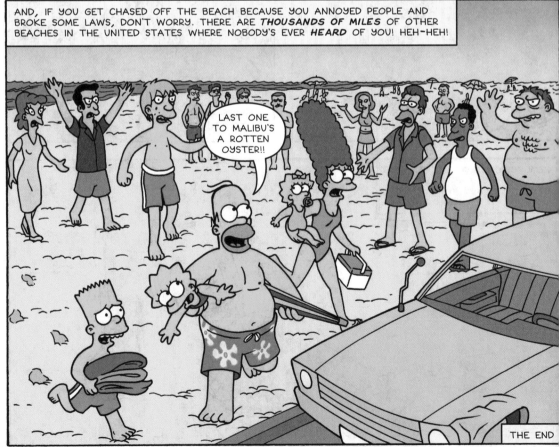

LAST ONE TO MALIBU'S A ROTTEN OYSTER!!

THE END

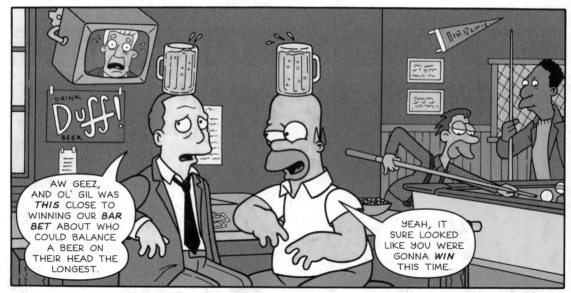

AW GEEZ, AND OL' GIL WAS *THIS* CLOSE TO WINNING OUR *BAR BET* ABOUT WHO COULD BALANCE A BEER ON THEIR HEAD THE LONGEST.

YEAH, IT SURE LOOKED LIKE YOU WERE GONNA *WIN* THIS TIME.

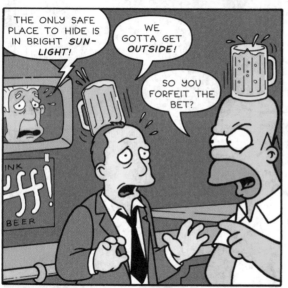

THE ONLY SAFE PLACE TO HIDE IS IN BRIGHT *SUN-LIGHT!*

WE GOTTA GET *OUTSIDE!*

SO YOU FORFEIT THE BET?

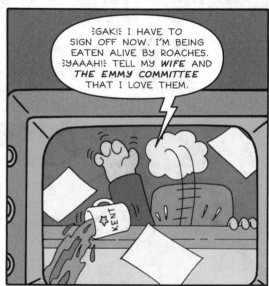

≩GAK!≩ I HAVE TO SIGN OFF NOW. I'M BEING EATEN ALIVE BY ROACHES. ≩YAAAH!≩ TELL MY *WIFE* AND *THE EMMY COMMITTEE* THAT I LOVE THEM.

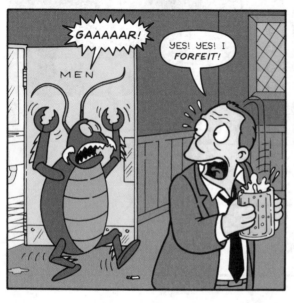

GAAAAAR!

YES! YES! I *FORFEIT!*

MEN

YAAAAH!

WAIT A MINUTE!

SUCKER

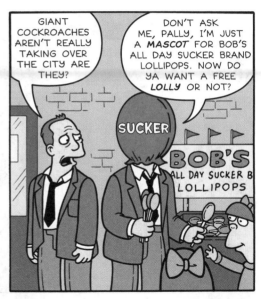

GIANT COCKROACHES AREN'T REALLY TAKING OVER THE CITY ARE THEY?

DON'T ASK ME, PALLY, I'M JUST A *MASCOT* FOR BOB'S ALL DAY SUCKER BRAND LOLLIPOPS. NOW DO YA WANT A FREE *LOLLY* OR NOT?

SUCKER

BOB'S ALL DAY SUCKER B LOLLIPOPS

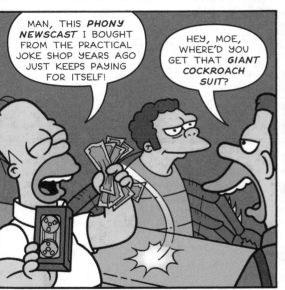

MAN, THIS *PHONY NEWSCAST* I BOUGHT FROM THE PRACTICAL JOKE SHOP YEARS AGO JUST KEEPS PAYING FOR ITSELF!

HEY, MOE, WHERE'D YOU GET THAT *GIANT COCKROACH SUIT?*

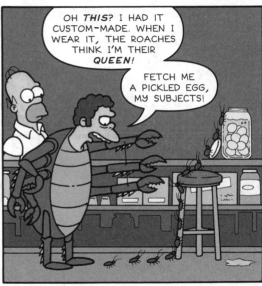

OH *THIS*? I HAD IT CUSTOM-MADE. WHEN I WEAR IT, THE ROACHES THINK I'M THEIR *QUEEN!*

FETCH ME A PICKLED EGG, MY SUBJECTS!

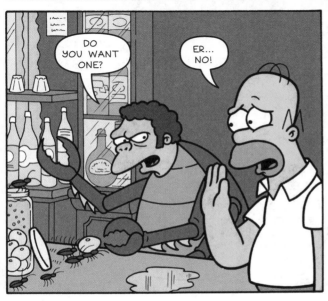

DO YOU WANT ONE?

ER... NO!

WELL, YOU *BOONDOGGLED* OL' GIL FAIR AND SQUARE!

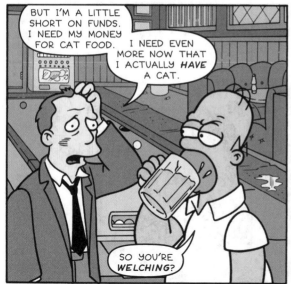

BUT I'M A LITTLE SHORT ON FUNDS. I NEED MY MONEY FOR CAT FOOD. I NEED EVEN MORE NOW THAT I ACTUALLY *HAVE* A CAT.

SO YOU'RE *WELCHING*?

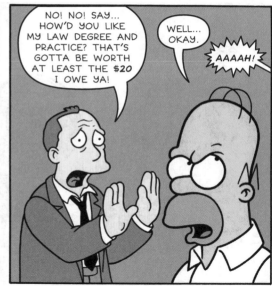

NO! NO! SAY... HOW'D YOU LIKE MY LAW DEGREE AND PRACTICE? THAT'S GOTTA BE WORTH AT LEAST THE *$20* I OWE YA!

WELL... OKAY.

AAAAH!

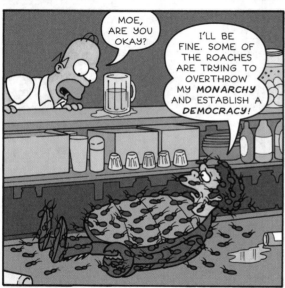

MOE, ARE YOU OKAY?

I'LL BE FINE. SOME OF THE ROACHES ARE TRYING TO OVERTHROW MY *MONARCHY* AND ESTABLISH A *DEMOCRACY*!

THE NEXT DAY...

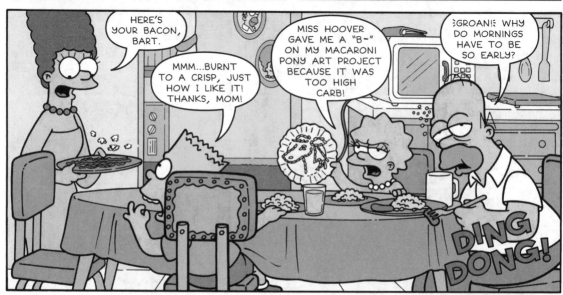

HERE'S YOUR BACON, BART.

MMM...BURNT TO A CRISP, JUST HOW I LIKE IT! THANKS, MOM!

MISS HOOVER GAVE ME A "B-" ON MY MACARONI PONY ART PROJECT BECAUSE IT WAS TOO HIGH CARB!

⁆GROAN!⁆ WHY DO MORNINGS HAVE TO BE SO EARLY?

DING DONG!

I'LL GET IT!

IF THAT'S FLANDERS, TELL HIM I DON'T KNOW WHO THREW UP IN HIS ROSE BUSHES LAST NIGHT!

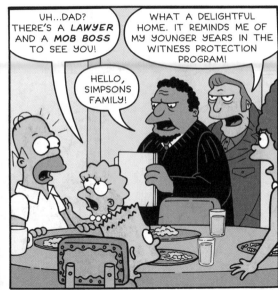

UH...DAD? THERE'S A *LAWYER* AND A *MOB BOSS* TO SEE YOU!

WHAT A DELIGHTFUL HOME. IT REMINDS ME OF MY YOUNGER YEARS IN THE WITNESS PROTECTION PROGRAM!

HELLO, SIMPSONS FAMILY!

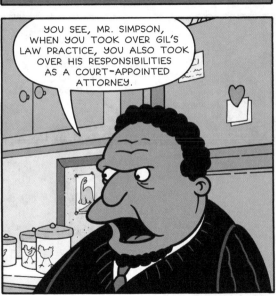

YOU SEE, MR. SIMPSON, WHEN YOU TOOK OVER GIL'S LAW PRACTICE, YOU ALSO TOOK OVER HIS RESPONSIBILITIES AS A COURT-APPOINTED ATTORNEY.

BUT HOMER BARELY UNDER-STANDS *THE LAW OF GRAVITY*!

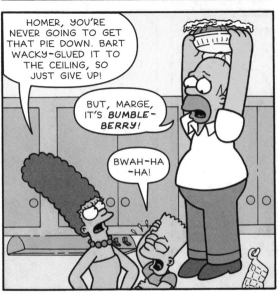

HOMER, YOU'RE NEVER GOING TO GET THAT PIE DOWN. BART WACKY-GLUED IT TO THE CEILING, SO JUST GIVE UP!

BUT, MARGE, IT'S *BUMBLE-BERRY*!

BWAH-HA-HA!

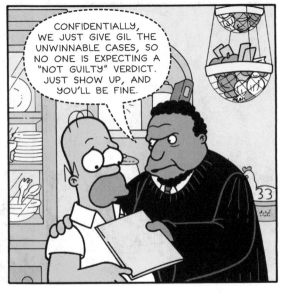

CONFIDENTIALLY, WE JUST GIVE GIL THE UNWINNABLE CASES, SO NO ONE IS EXPECTING A "NOT GUILTY" VERDICT. JUST SHOW UP, AND YOU'LL BE FINE.

33

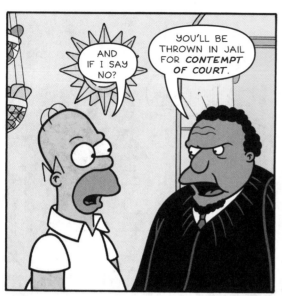

AND IF I SAY NO?

YOU'LL BE THROWN IN JAIL FOR *CONTEMPT OF COURT*.

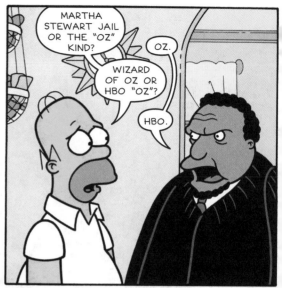

MARTHA STEWART JAIL OR THE "OZ" KIND?

OZ.

WIZARD OF OZ OR HBO "OZ"?

HBO.

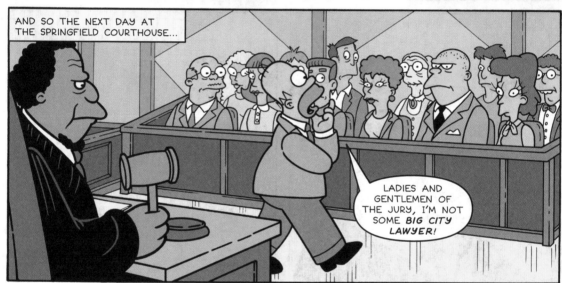

AND SO THE NEXT DAY AT THE SPRINGFIELD COURTHOUSE...

LADIES AND GENTLEMEN OF THE JURY, I'M NOT SOME *BIG CITY LAWYER*!

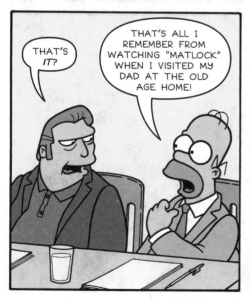

THAT'S *IT*?

THAT'S ALL I REMEMBER FROM WATCHING "MATLOCK" WHEN I VISITED MY DAD AT THE OLD AGE HOME!

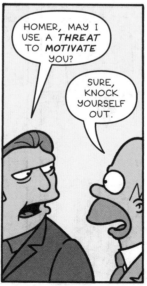

HOMER, MAY I USE A *THREAT* TO *MOTIVATE* YOU?

SURE, KNOCK YOURSELF OUT.

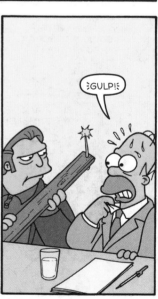

¦GULP!¦

SHORTLY...

WE, THE JURY, FIND THE DEFENDANT "NOT GUILTY" DUE TO BEING A COMPLEX CHARACTER WHO HELPS US TO REFLECT ON OUR OWN FAMILY DYNAMICS!

HOMER, I AM IMPRESSED!

I JUST REMEMBERED HOW BORING IT WAS WHEN I WAS ON A JURY! AND THE ACTORS WERE IN TOWN DOING A DINNER THEATER PRODUCTION OF "OUR TOWN"!

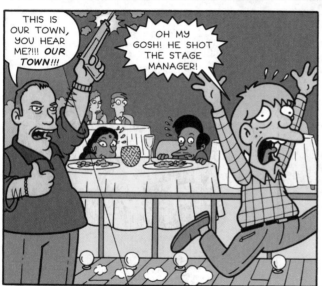
THIS IS OUR TOWN, YOU HEAR ME?!!! OUR TOWN!!!

OH MY GOSH! HE SHOT THE STAGE MANAGER!

YOU WON THIS TIME, SIMPSON, BUT DON'T GET USED TO IT. IT WON'T HAPPEN AGAIN!

THE NEXT DAY...

DUDE, YOU GET ME OFF THIS ASSAULT CHARGE, AND I'LL TOTALLY GIVE BACK THE STUFF I STOLE FROM YOUR HOUSE THE LAST COUPLE OF TIMES I ROBBED IT!

LET ME START BY SAYING AB IMO PECTORE THAT WHILE THE DEFENDANT CLAIMS INNOCENCE, I SAY A CONTRARIO. HIS ARGUMENT IN A BAR WITH A BIKER WENT FROM A VERBIS AD VERBERA RESULTING IN A BRUTAL ASSAULT.

HE'S USING LATIN! HOW DO YOU FIGHT THAT?

≋SIGH≋

LATER THAT NIGHT...

SPRINGFIELD LASERDOME

NEXT WEEK-LASER PINK FLOYD
THIS WEEK-SNAKE'S DEFENSE

I, LIKE, DON'T WANT TO FIGHT!

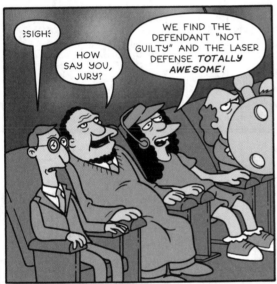

≷SIGH≷

HOW SAY YOU, JURY?

WE FIND THE DEFENDANT "NOT GUILTY" AND THE LASER DEFENSE *TOTALLY AWESOME!*

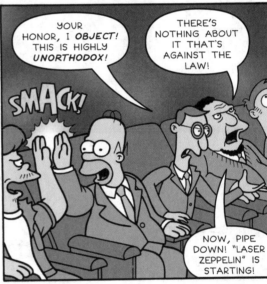

YOUR HONOR, I *OBJECT!* THIS IS HIGHLY *UNORTHODOX!*

SMACK!

THERE'S NOTHING ABOUT IT THAT'S AGAINST THE LAW!

NOW, PIPE DOWN! "LASER ZEPPELIN" IS STARTING!

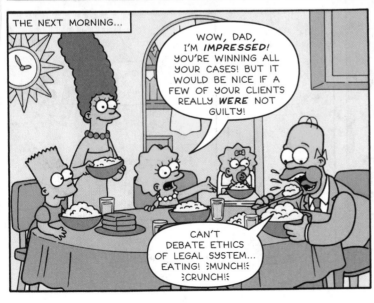

THE NEXT MORNING...

WOW, DAD, I'M *IMPRESSED!* YOU'RE WINNING ALL YOUR CASES! BUT IT WOULD BE NICE IF A FEW OF YOUR CLIENTS REALLY *WERE* NOT GUILTY!

CAN'T DEBATE ETHICS OF LEGAL SYSTEM... EATING! ≷MUNCH!≷ ≷CRUNCH!≷

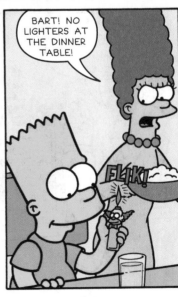

BART! NO LIGHTERS AT THE DINNER TABLE!

FLIK!

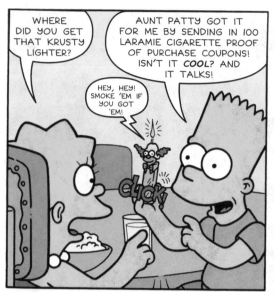

WHERE DID YOU GET THAT KRUSTY LIGHTER?

AUNT PATTY GOT IT FOR ME BY SENDING IN 100 LARAMIE CIGARETTE PROOF OF PURCHASE COUPONS! ISN'T IT *COOL*? AND IT TALKS!

HEY, HEY! SMOKE 'EM IF YOU GOT 'EM!

CLICK

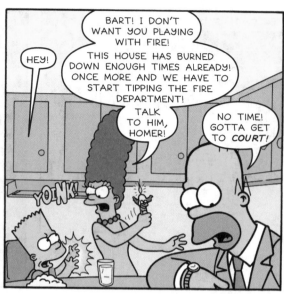

BART! I DON'T WANT YOU PLAYING WITH FIRE!

THIS HOUSE HAS BURNED DOWN ENOUGH TIMES ALREADY! ONCE MORE AND WE HAVE TO START TIPPING THE FIRE DEPARTMENT!

HEY!

TALK TO HIM, HOMER!

NO TIME! GOTTA GET TO *COURT*!

YOINK!

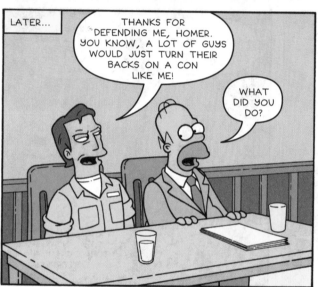

LATER...

THANKS FOR DEFENDING ME, HOMER. YOU KNOW, A LOT OF GUYS WOULD JUST TURN THEIR BACKS ON A CON LIKE ME!

WHAT DID YOU DO?

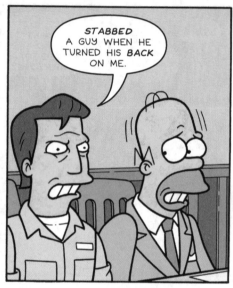

STABBED A GUY WHEN HE TURNED HIS *BACK* ON ME.

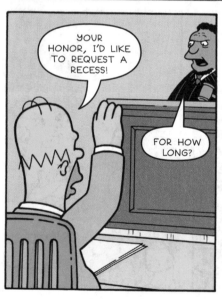

YOUR HONOR, I'D LIKE TO REQUEST A RECESS!

FOR HOW LONG?

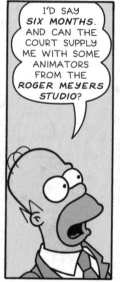

I'D SAY *SIX MONTHS*. AND CAN THE COURT SUPPLY ME WITH SOME ANIMATORS FROM THE *ROGER MEYERS STUDIO*?

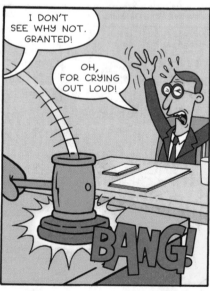

I DON'T SEE WHY NOT. GRANTED!

OH, FOR CRYING OUT LOUD!

BANG!

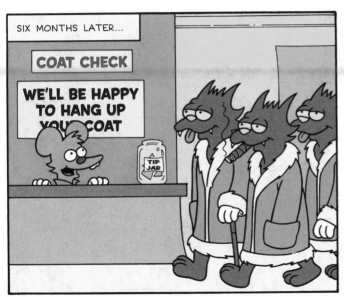

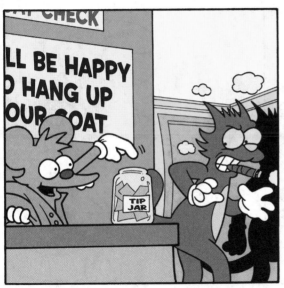

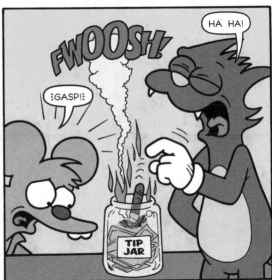

WE, THE JURY, FIND THE DEFENDANT "NOT GUILTY" DUE TO *BACK STABBING* BEING *HILARIOUS!*

THE END

≥GROAN≤

I'VE LEARNED MY LESSON. I'LL NEVER STAB AGAIN.

YOU'RE STABBING ME *NOW!*

MAN, WHY CAN'T PEOPLE LET A CON CATCH A BREAK IN THIS TOWN?!

I'M SORRY!

NOT SO FAST, SIMPSON! YOU'VE GOT ONE MORE CLIENT ON YOUR ROSTER TODAY.

FINE. BRING IT ON! LIKE THE ICING SAID TO THE CINNAMON BUN, "I'M ON A ROLL!"

WHAT IS IT *THIS* TIME? JAYWALKING? COUNTERFEITING?

ARSON!

BART!

I DIDN'T DO IT!

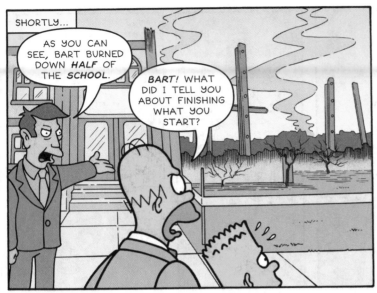

SHORTLY...

AS YOU CAN SEE, BART BURNED DOWN *HALF* OF THE *SCHOOL*.

BART! WHAT DID I TELL YOU ABOUT FINISHING WHAT YOU START?

I DIDN'T START THAT FIRE! I SWEAR ON *GRAMPA'S GRAVE!*

DO YOU HAVE TO CARRY THAT *EVERY-WHERE* WE TAKE YOU?

IF I LEAVE IT AT THE HOME, JASPER'LL STEAL IT!

ABRAHAM SIMPSON

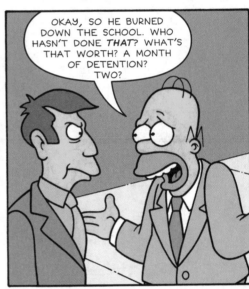

OKAY, SO HE BURNED DOWN THE SCHOOL. WHO HASN'T DONE *THAT*? WHAT'S THAT WORTH? A MONTH OF DETENTION? TWO?

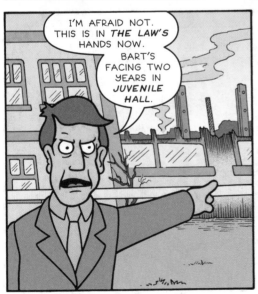

I'M AFRAID NOT. THIS IS IN *THE LAW'S* HANDS NOW. BART'S FACING TWO YEARS IN *JUVENILE HALL.*

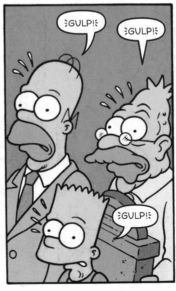

⅏GULP!⅏

⅏GULP!⅏

⅏GULP!⅏

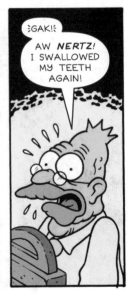

⅏GAK!⅏
AW *NERTZ!* I SWALLOWED MY TEETH AGAIN!

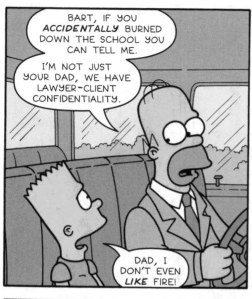

BART, IF YOU *ACCIDENTALLY* BURNED DOWN THE SCHOOL YOU CAN TELL ME.

I'M NOT JUST YOUR DAD, WE HAVE LAWYER-CLIENT CONFIDENTIALITY.

DAD, I DON'T EVEN *LIKE* FIRE!

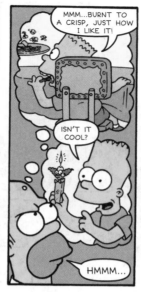

MMM...BURNT TO A CRISP, JUST HOW I LIKE IT!

ISN'T IT COOL?

HMMM...

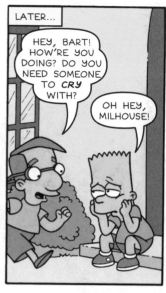

LATER...

HEY, BART! HOW'RE YOU DOING? DO YOU NEED SOMEONE TO *CRY* WITH?

OH HEY, MILHOUSE!

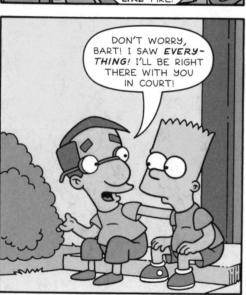

DON'T WORRY, BART! I SAW *EVERYTHING!* I'LL BE RIGHT THERE WITH YOU IN COURT!

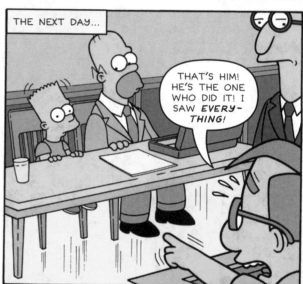

THE NEXT DAY...

THAT'S HIM! HE'S THE ONE WHO DID IT! I SAW *EVERYTHING!*

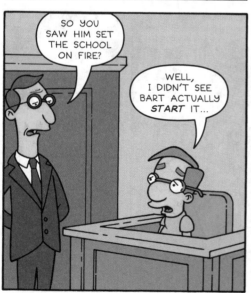

SO YOU SAW HIM SET THE SCHOOL ON FIRE?

WELL, I DIDN'T SEE BART ACTUALLY *START* IT...

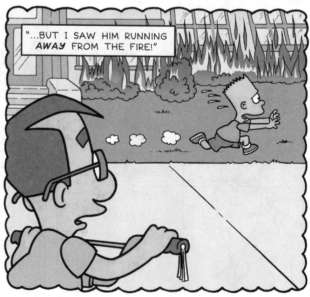

"...BUT I SAW HIM RUNNING *AWAY* FROM THE FIRE!"

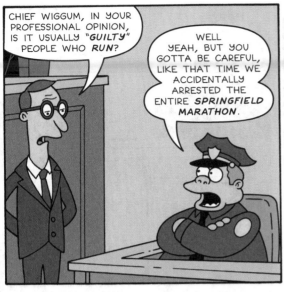

CHIEF WIGGUM, IN YOUR PROFESSIONAL OPINION, IS IT USUALLY "GUILTY" PEOPLE WHO RUN?

WELL YEAH, BUT YOU GOTTA BE CAREFUL, LIKE THAT TIME WE ACCIDENTALLY ARRESTED THE ENTIRE SPRINGFIELD MARATHON.

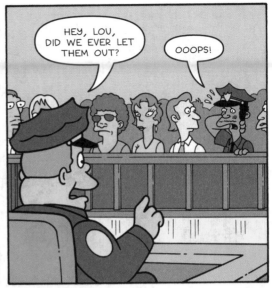

HEY, LOU, DID WE EVER LET THEM OUT?

OOOPS!

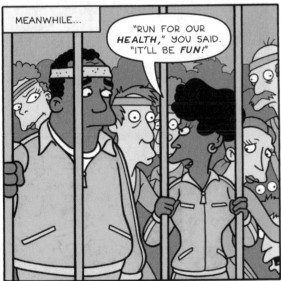

MEANWHILE...

"RUN FOR OUR HEALTH," YOU SAID. "IT'LL BE FUN!"

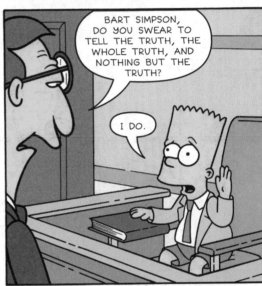

BART SIMPSON, DO YOU SWEAR TO TELL THE TRUTH, THE WHOLE TRUTH, AND NOTHING BUT THE TRUTH?

I DO.

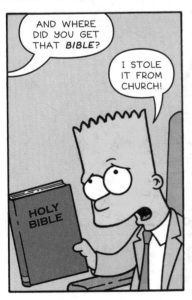

AND WHERE DID YOU GET THAT BIBLE?

I STOLE IT FROM CHURCH!

HOLY BIBLE

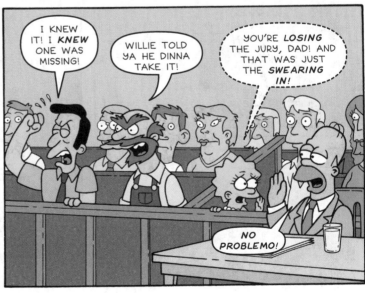

I KNEW IT! I KNEW ONE WAS MISSING!

WILLIE TOLD YA HE DINNA TAKE IT!

YOU'RE LOSING THE JURY, DAD! AND THAT WAS JUST THE SWEARING IN!

NO PROBLEMO!

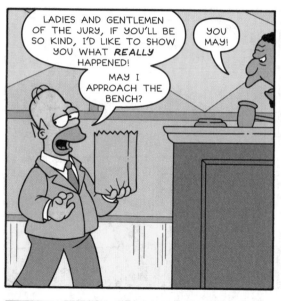

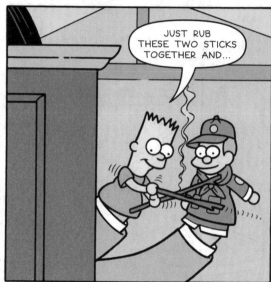

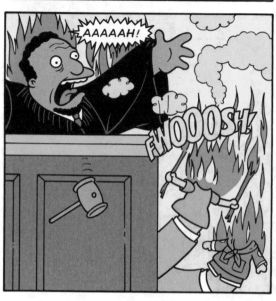

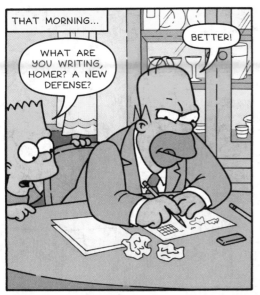

THAT MORNING...

WHAT ARE YOU WRITING, HOMER? A NEW DEFENSE?

BETTER!

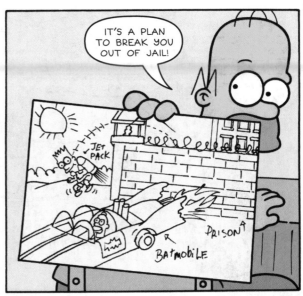

IT'S A PLAN TO BREAK YOU OUT OF JAIL!

JET PACK

PRISON

BATMOBILE

DAD, YOU *CAN'T* GIVE UP *NOW*!

BUT *FLASHY STUNTS* ARE ALL I HAVE!

I'LL ASK AROUND AT SCHOOL AND SEE IF ANYONE SAW SOMETHING. YOU COMING?

CAN'T. I'M SUSPENDED UNTIL AFTER THE TRIAL.

YOU'RE *LUCKY*. I WISH *I* COULD STAY HOME!

WHAT? BUT YOU *LOVE* SCHOOL!

SINCE HALF THE SCHOOL IS GONE, THEY'VE HAD TO *DOUBLE UP* THE CLASSES.

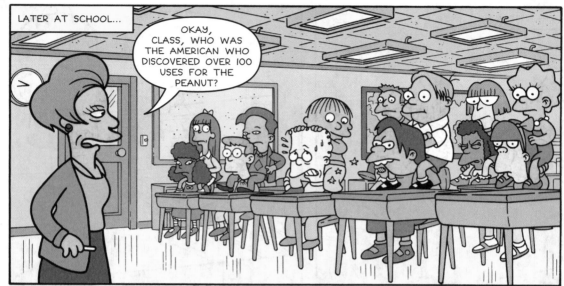

LATER AT SCHOOL...

OKAY, CLASS, WHO WAS THE AMERICAN WHO DISCOVERED OVER 100 USES FOR THE PEANUT?

:WHISPER!:

GEORGE WASHINGTON CARVER?

WELL DONE, NELSON! YOUR GRADES HAVE CERTAINLY GONE UP LATELY. FROM A "D" TO AN "A" IN HISTORY!

RIIING!

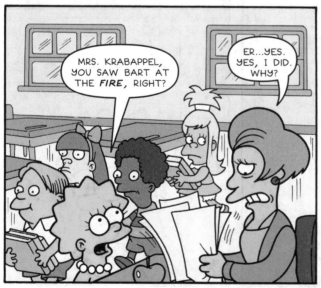

MRS. KRABAPPEL, YOU SAW BART AT THE FIRE, RIGHT?

ER...YES. YES, I DID. WHY?

ARE YOU OKAY? YOU SEEM REALLY NERVOUS.

WELL, I GAVE UP SMOKING RECENTLY.

SO WHAT DID YOU SEE?

I WAS IN THE SUPPLY ROOM ON THE SECOND FLOOR GETTING...UM... PAPER.

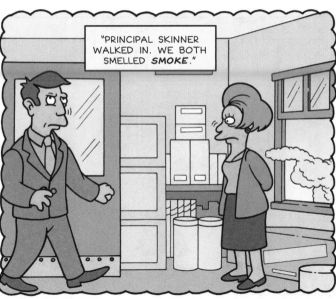

"PRINCIPAL SKINNER WALKED IN. WE BOTH SMELLED *SMOKE*."

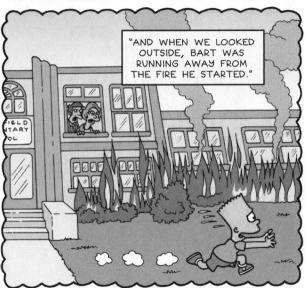

"AND WHEN WE LOOKED OUTSIDE, BART WAS RUNNING AWAY FROM THE FIRE HE STARTED."

PRINCIPAL SKINNER, CAN I TALK TO YOU?

JUST A MOMENT, LISA, I'M TALKING TO SUPERINTENDENT CHALMERS.

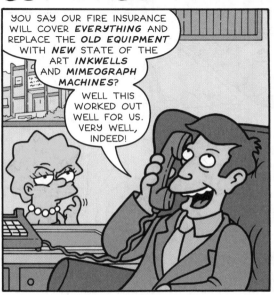

YOU SAY OUR FIRE INSURANCE WILL COVER *EVERYTHING* AND REPLACE THE *OLD EQUIPMENT* WITH *NEW* STATE OF THE ART *INKWELLS* AND *MIMEOGRAPH MACHINES*?

WELL THIS WORKED OUT WELL FOR US. VERY WELL, INDEED!

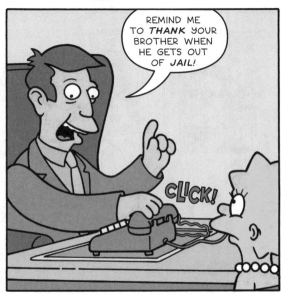

REMIND ME TO *THANK* YOUR BROTHER WHEN HE GETS OUT OF *JAIL!*

CLICK!

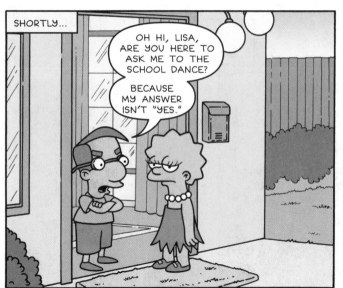

SHORTLY...

OH HI, LISA, ARE YOU HERE TO ASK ME TO THE SCHOOL DANCE?

BECAUSE MY ANSWER ISN'T "YES."

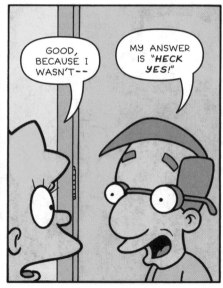

GOOD, BECAUSE I WASN'T--

MY ANSWER IS *"HECK YES!"*

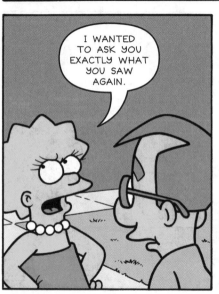

I WANTED TO ASK YOU EXACTLY WHAT YOU SAW AGAIN.

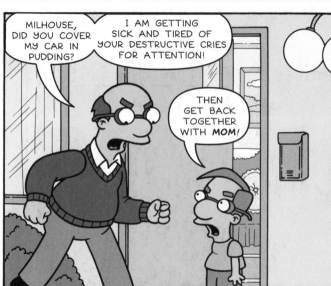

MILHOUSE, DID YOU COVER MY CAR IN PUDDING?

I AM GETTING SICK AND TIRED OF YOUR DESTRUCTIVE CRIES FOR ATTENTION!

THEN GET BACK TOGETHER WITH *MOM!*

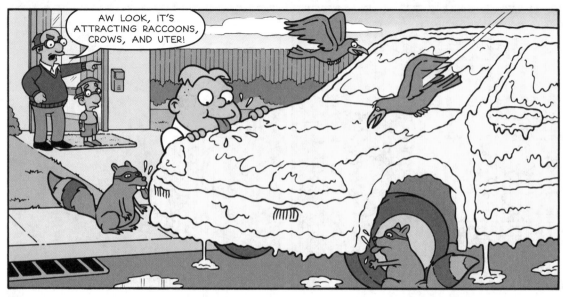

AW LOOK, IT'S ATTRACTING RACCOONS, CROWS, AND UTER!

LATER THAT DAY...

CHIEF WIGGUM, WOULD YOU MIND IF I LOOKED AT THE CRIME SCENE?

SORRY, LISA--

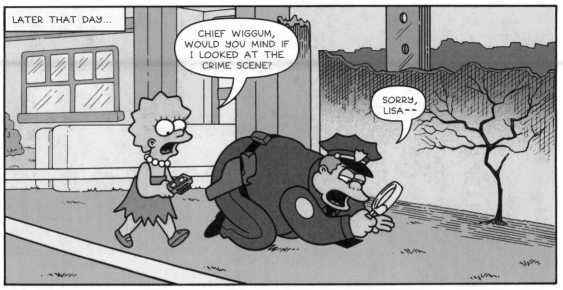

HEY, CHIEF! I FOUND A NEST OF ANTS OVER HERE WE CAN BURN!

OH BOY!

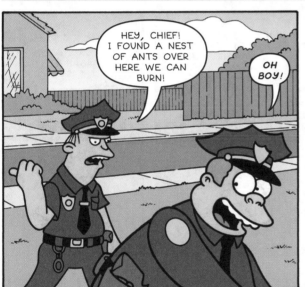

ACCORDING TO REPORTS, THIS AREA WAS THE START OF THE FIRE. I'M HOPING I CAN FIND SOME EVIDENCE THAT POINTS AWAY FROM--

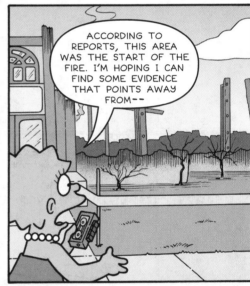

BART.

BART

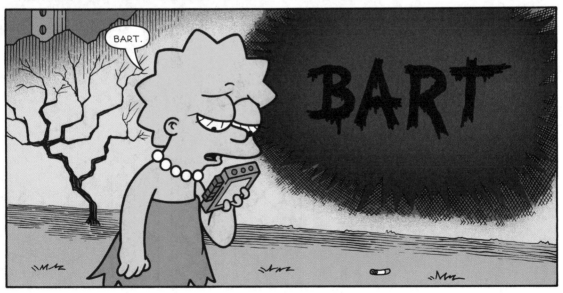

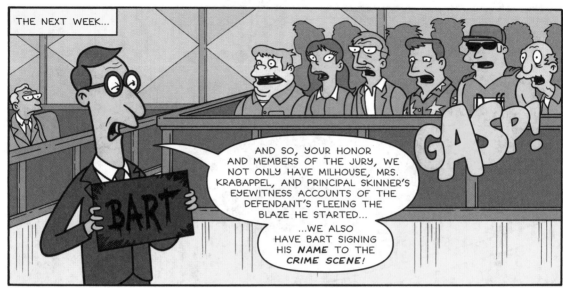

THE NEXT WEEK...

AND SO, YOUR HONOR AND MEMBERS OF THE JURY, WE NOT ONLY HAVE MILHOUSE, MRS. KRABAPPEL, AND PRINCIPAL SKINNER'S EYEWITNESS ACCOUNTS OF THE DEFENDANT'S FLEEING THE BLAZE HE STARTED...

...WE ALSO HAVE BART SIGNING HIS *NAME* TO THE *CRIME SCENE!*

GASP!

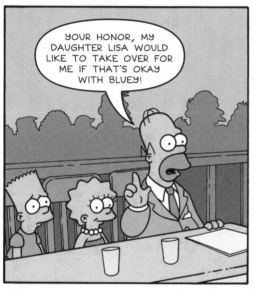

YOUR HONOR, MY DAUGHTER LISA WOULD LIKE TO TAKE OVER FOR ME IF THAT'S OKAY WITH BLUEY!

YOU WANT AN EIGHT-YEAR-OLD GIRL TO TRY THE CASE? *SUUUUUURE* THAT'S FINE WITH ME.

I CALL *EDNA KRABAPPEL* TO THE STAND!

NOW, MRS. KRABAPPEL, MAY I REMIND YOU YOU'RE STILL UNDER OATH!

YES.

THEN PLEASE TELL THE COURT ...DID YOU QUIT SMOKING?

I DON'T SEE WHAT THAT HAS TO DO WITH ANYTHING.

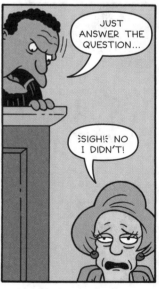

JUST ANSWER THE QUESTION...

≡SIGH!≡ NO I DIDN'T!

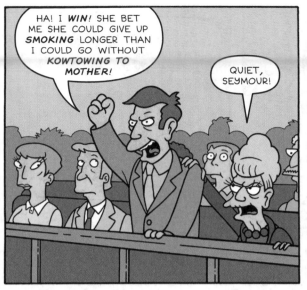

HA! I **WIN!** SHE BET ME SHE COULD GIVE UP **SMOKING** LONGER THAN I COULD GO WITHOUT **KOWTOWING TO MOTHER!**

QUIET, SEYMOUR!

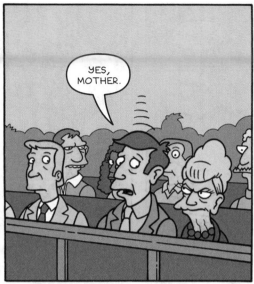

YES, MOTHER.

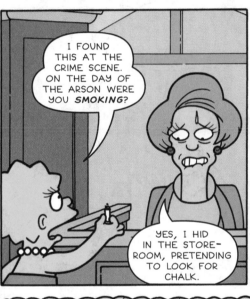

I FOUND THIS AT THE CRIME SCENE. ON THE DAY OF THE ARSON WERE YOU **SMOKING?**

YES, I HID IN THE STORE-ROOM, PRETENDING TO LOOK FOR CHALK.

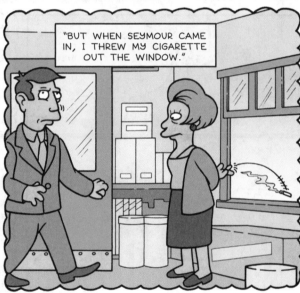

"BUT WHEN SEYMOUR CAME IN, I THREW MY CIGARETTE OUT THE WINDOW."

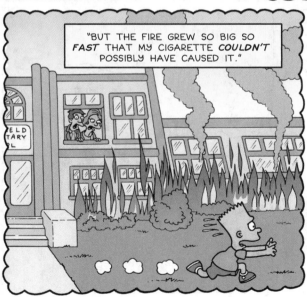

"BUT THE FIRE GREW SO BIG SO **FAST** THAT MY CIGARETTE **COULDN'T** POSSIBLY HAVE CAUSED IT."

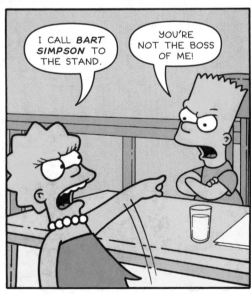

I CALL **BART SIMPSON** TO THE STAND.

YOU'RE NOT THE BOSS OF ME!

BART!

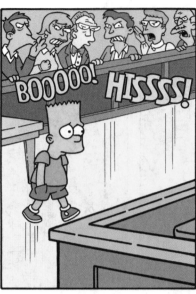

BOOOOO! HISSSS!

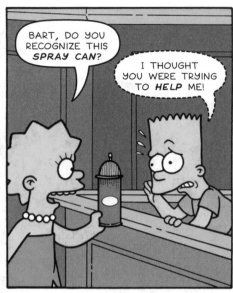

BART, DO YOU RECOGNIZE THIS **SPRAY CAN?**

I THOUGHT YOU WERE TRYING TO **HELP** ME!

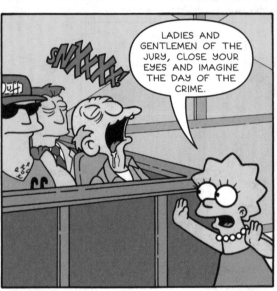

LADIES AND GENTLEMEN OF THE JURY, CLOSE YOUR EYES AND IMAGINE THE DAY OF THE CRIME.

SNXXXX!

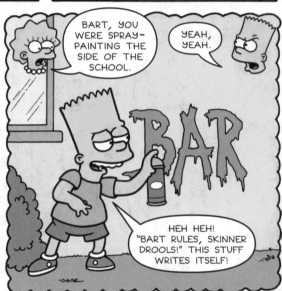

BART, YOU WERE SPRAY-PAINTING THE SIDE OF THE SCHOOL.

YEAH, YEAH.

HEH HEH! "BART RULES, SKINNER DROOLS!" THIS STUFF WRITES ITSELF!

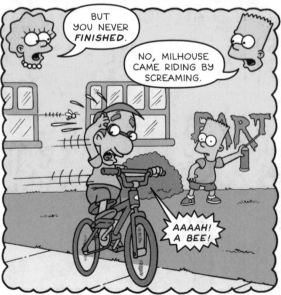

BUT YOU NEVER **FINISHED.**

NO, MILHOUSE CAME RIDING BY SCREAMING.

AAAAH! A BEE!

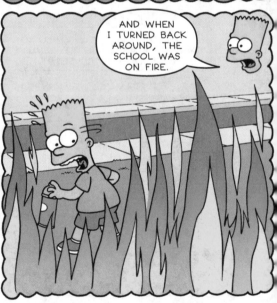

AND WHEN I TURNED BACK AROUND, THE SCHOOL WAS ON FIRE.

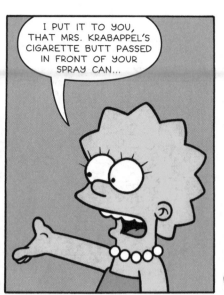

I PUT IT TO YOU, THAT MRS. KRABAPPEL'S CIGARETTE BUTT PASSED IN FRONT OF YOUR SPRAY CAN...

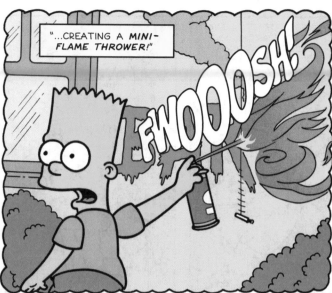

"...CREATING A *MINI-FLAME THROWER!*"

FWOOOOSH!

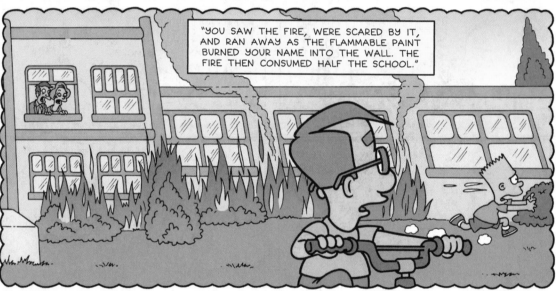

"YOU SAW THE FIRE, WERE SCARED BY IT, AND RAN AWAY AS THE FLAMMABLE PAINT BURNED YOUR NAME INTO THE WALL. THE FIRE THEN CONSUMED HALF THE SCHOOL."

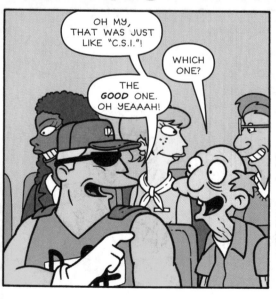

OH MY, THAT WAS JUST LIKE "C.S.I."!

WHICH ONE?

THE *GOOD* ONE. OH YEAAAH!

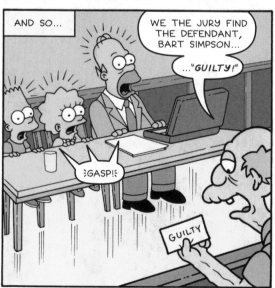

AND SO...

WE THE JURY FIND THE DEFENDANT, BART SIMPSON...

..."*GUILTY!*"

¡GASP!¡

GUILTY

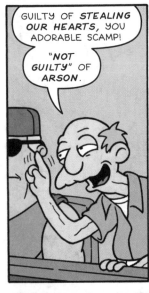

GUILTY OF *STEALING OUR HEARTS*, YOU ADORABLE SCAMP!

"*NOT GUILTY*" OF *ARSON*.

WHEW! THANKS, LISA!

BY THE WAY, IF ANYONE ASKS, THIS HUG NEVER HAPPENED.

AW, THAT WAS SOME GREAT LAWYERING, LITTLE GIRL. MADE ME MISS THE GOOD OLD DAYS BEFORE I BECAME A JANITOR!

OH WELL, I'D BETTER GET RID OF THIS HORNET NEST I FOUND IN THE COURT ATTIC.

OOOPS!

AAAAAH!

BZZZZZZ!

GIL, YOU CAN HAVE YOUR PRACTICE BACK! I'M NOT CUT OUT FOR THE LAW GAME. MY GAME'S MORE...

...WHAT'S THAT ONE WITH THE *MOUSETRAP*?

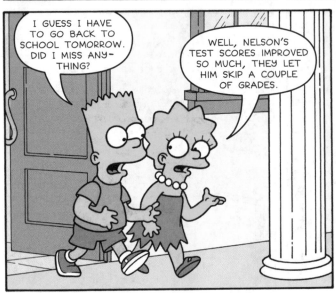

I GUESS I HAVE TO GO BACK TO SCHOOL TOMORROW. DID I MISS ANY-THING?

WELL, NELSON'S TEST SCORES IMPROVED SO MUCH, THEY LET HIM SKIP A COUPLE OF GRADES.

HAND OVER YOUR LUNCH MONEY, OR I'LL POUND YA!

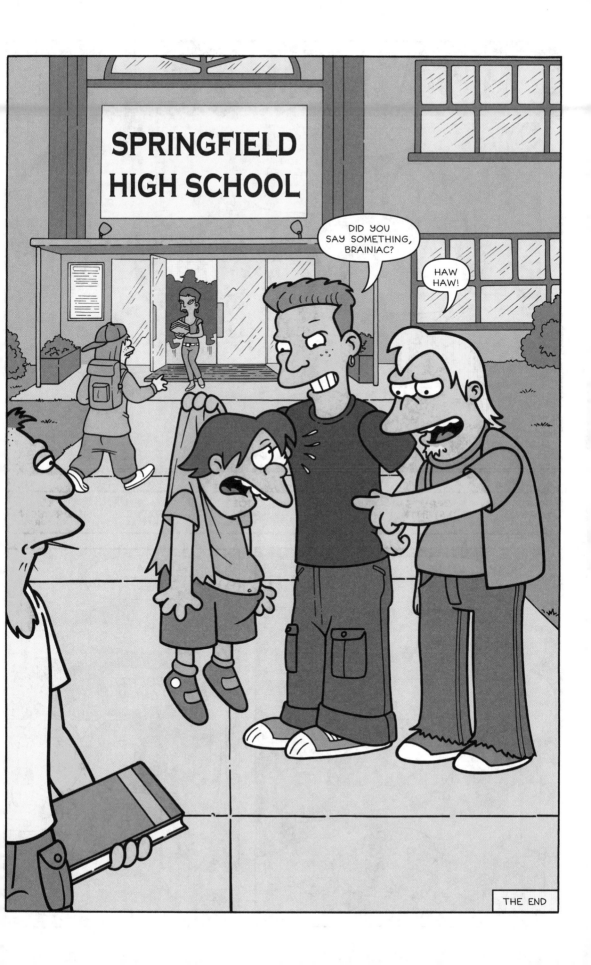

THE END

A ROAMING HOLIDAY

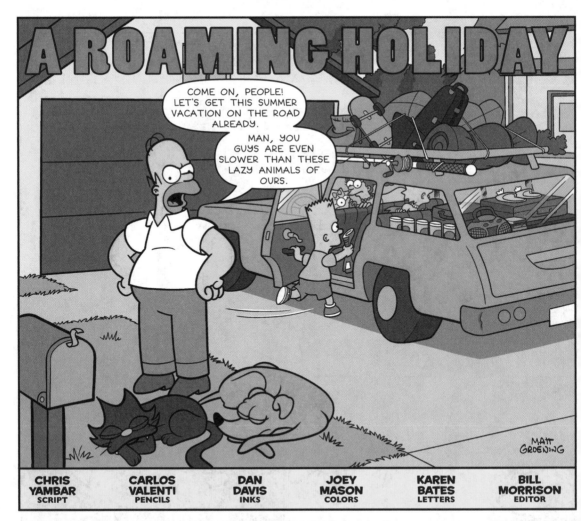

COME ON, PEOPLE! LET'S GET THIS SUMMER VACATION ON THE ROAD ALREADY.

MAN, YOU GUYS ARE EVEN SLOWER THAN THESE LAZY ANIMALS OF OURS.

MATT GROENING

CHRIS YAMBAR SCRIPT

CARLOS VALENTI PENCILS

DAN DAVIS INKS

JOEY MASON COLORS

KAREN BATES LETTERS

BILL MORRISON EDITOR

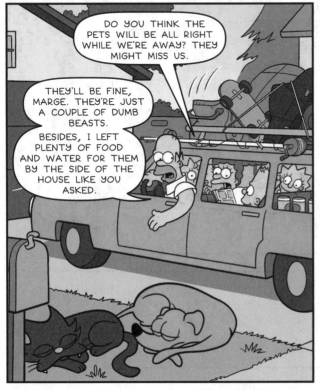

DO YOU THINK THE PETS WILL BE ALL RIGHT WHILE WE'RE AWAY? THEY MIGHT MISS US.

THEY'LL BE FINE, MARGE. THEY'RE JUST A COUPLE OF DUMB BEASTS.

BESIDES, I LEFT PLENTY OF FOOD AND WATER FOR THEM BY THE SIDE OF THE HOUSE LIKE YOU ASKED.

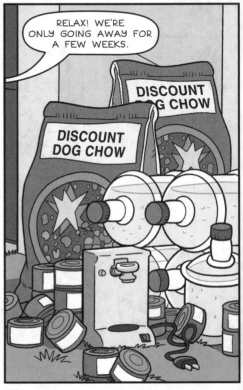

RELAX! WE'RE ONLY GOING AWAY FOR A FEW WEEKS.

DISCOUNT DOG CHOW

DISCOUNT DOG CHOW

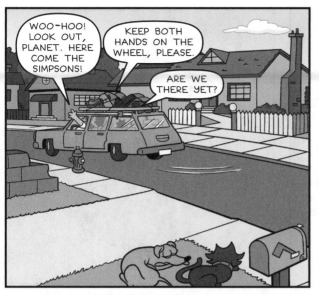

WOO-HOO! LOOK OUT, PLANET. HERE COME THE SIMPSONS!

KEEP BOTH HANDS ON THE WHEEL, PLEASE.

ARE WE THERE YET?

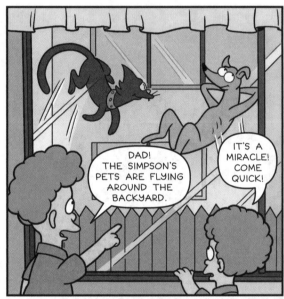

DAD! THE SIMPSON'S PETS ARE FLYING AROUND THE BACKYARD.

IT'S A MIRACLE! COME QUICK!

:SIGH: I KNEW I NEVER SHOULD HAVE BOUGHT YOU BOYS THAT SUGARY BREAKFAST CEREAL. IT ALWAYS LEADS TO BLASPHEMY.

NO FISHING

DO NOT TOUCH THE DISPLAYS

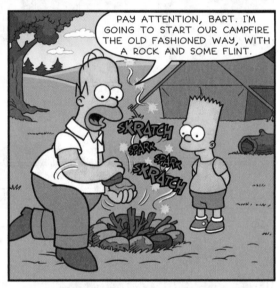

PAY ATTENTION, BART. I'M GOING TO START OUR CAMPFIRE THE OLD FASHIONED WAY, WITH A ROCK AND SOME FLINT.

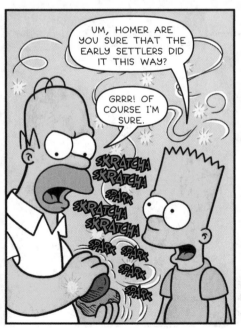

UM, HOMER ARE YOU SURE THAT THE EARLY SETTLERS DID IT THIS WAY?

GRRR! OF COURSE I'M SURE.

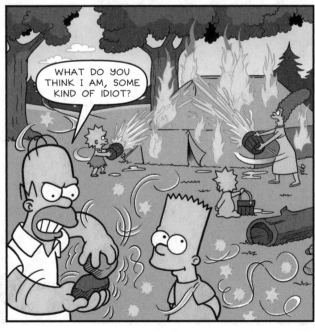

WHAT DO YOU THINK I AM, SOME KIND OF IDIOT?

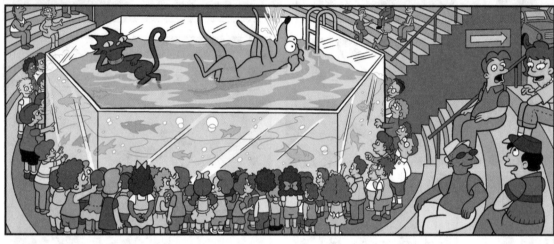
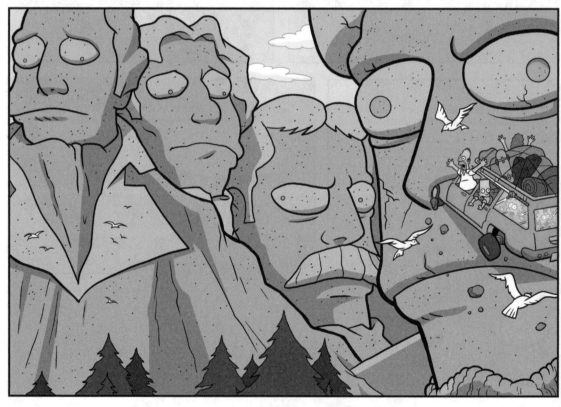

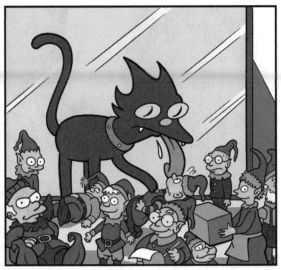

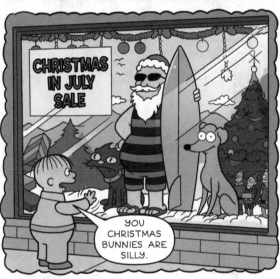

YOU CHRISTMAS BUNNIES ARE SILLY.

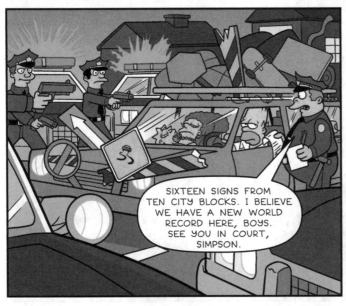

SIXTEEN SIGNS FROM TEN CITY BLOCKS. I BELIEVE WE HAVE A NEW WORLD RECORD HERE, BOYS. SEE YOU IN COURT, SIMPSON.

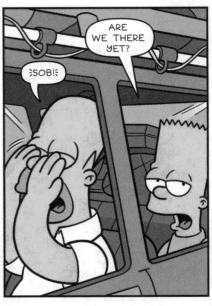

ARE WE THERE YET?

:SOB!:

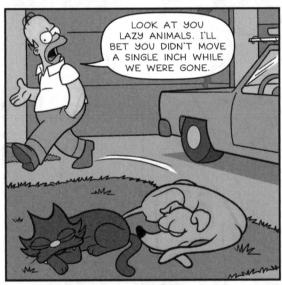

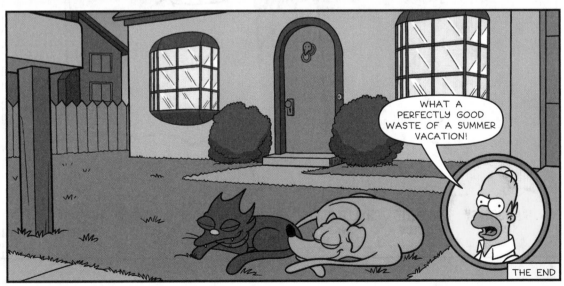

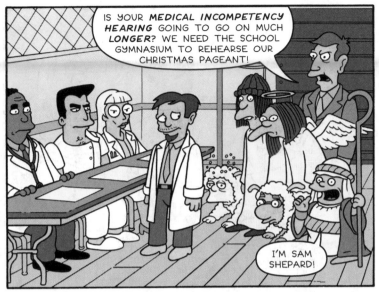

IS YOUR **MEDICAL INCOMPETENCY HEARING** GOING TO GO ON MUCH **LONGER**? WE NEED THE SCHOOL GYMNASIUM TO REHEARSE OUR CHRISTMAS PAGEANT!

I'M SAM SHEPARD!

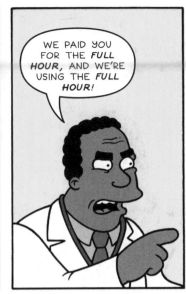

WE PAID YOU FOR THE **FULL HOUR**, AND WE'RE USING THE **FULL HOUR**!

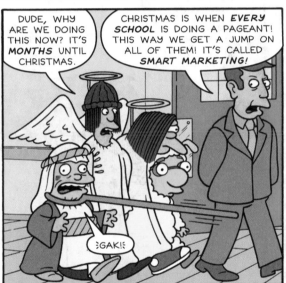

DUDE, WHY ARE WE DOING THIS NOW? IT'S **MONTHS** UNTIL CHRISTMAS.

CHRISTMAS IS WHEN **EVERY SCHOOL** IS DOING A PAGEANT! THIS WAY WE GET A JUMP ON ALL OF THEM! IT'S CALLED **SMART MARKETING**!

;GAK!;

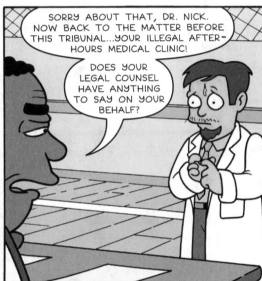

SORRY ABOUT THAT, DR. NICK. NOW BACK TO THE MATTER BEFORE THIS TRIBUNAL...YOUR ILLEGAL AFTER-HOURS MEDICAL CLINIC!

DOES YOUR LEGAL COUNSEL HAVE ANYTHING TO SAY ON YOUR BEHALF?

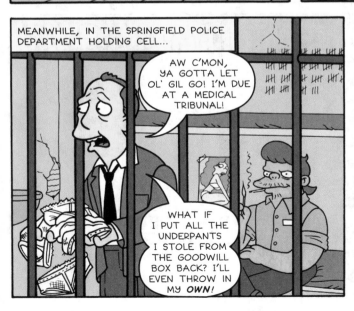

MEANWHILE, IN THE SPRINGFIELD POLICE DEPARTMENT HOLDING CELL...

AW C'MON, YA GOTTA LET OL' GIL GO! I'M DUE AT A MEDICAL TRIBUNAL!

WHAT IF I PUT ALL THE UNDERPANTS I STOLE FROM THE GOODWILL BOX BACK? I'LL EVEN THROW IN MY **OWN**!

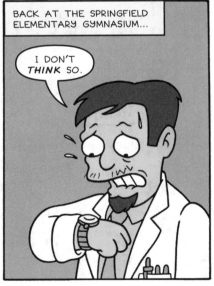

BACK AT THE SPRINGFIELD ELEMENTARY GYMNASIUM...

I DON'T **THINK** SO.

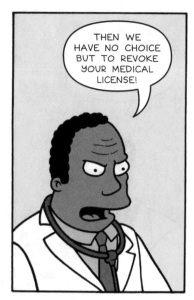

THEN WE HAVE NO CHOICE BUT TO REVOKE YOUR MEDICAL LICENSE!

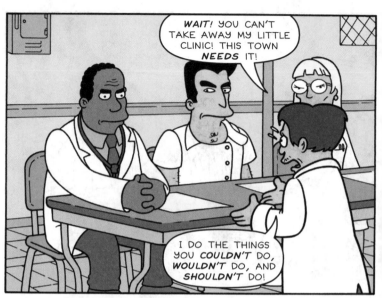

WAIT! YOU CAN'T TAKE AWAY MY LITTLE CLINIC! THIS TOWN *NEEDS* IT!

I DO THE THINGS YOU *COULDN'T* DO, *WOULDN'T* DO, AND *SHOULDN'T* DO!

EXPLAIN!

OKEY-DOKEY!

HERE'S A CASE I LIKE TO CALL...

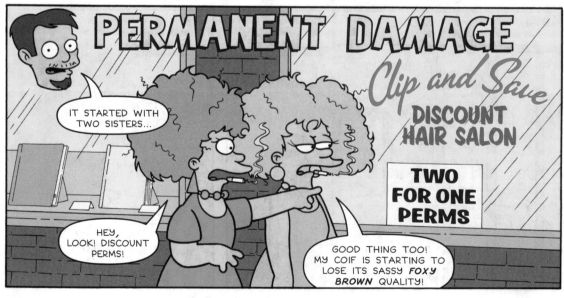

PERMANENT DAMAGE

Clip and Save

DISCOUNT HAIR SALON

TWO FOR ONE PERMS

IT STARTED WITH TWO SISTERS...

HEY, LOOK! DISCOUNT PERMS!

GOOD THING TOO! MY COIF IS STARTING TO LOSE ITS SASSY *FOXY BROWN* QUALITY!

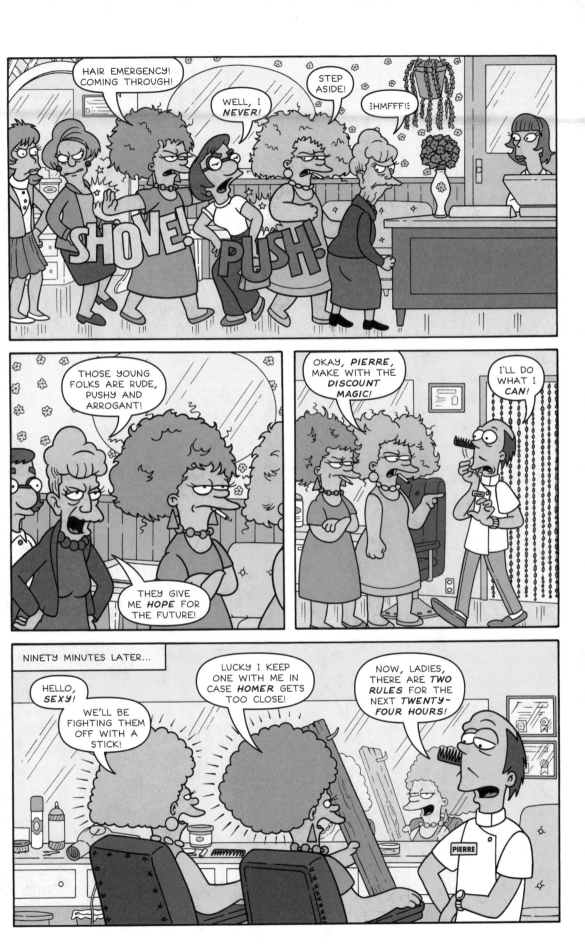

DON'T GET YOUR HAIR WET AND...

SLAP!

SLAP!

...ABSOLUTELY **NO** SMOKING!

WELL 24 HOURS IS NO BIG DEAL. STILL, BETTER TOSS THESE! OUT OF SIGHT, OUT OF MIND!

YEAH, WE SMOKE BECAUSE WE **LIKE** IT, NOT BECAUSE WE'RE **ADDICTED**!

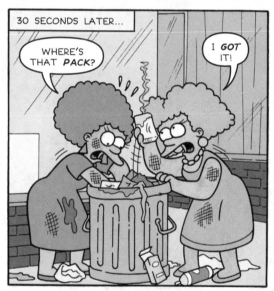

30 SECONDS LATER...

WHERE'S THAT **PACK**?

I **GOT** IT!

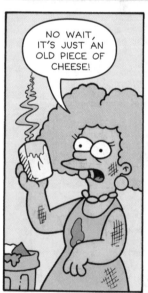

NO WAIT, IT'S JUST AN OLD PIECE OF CHEESE!

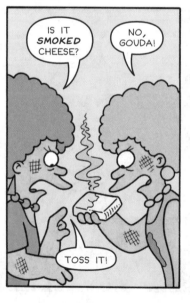

IS IT **SMOKED** CHEESE?

NO, GOUDA!

TOSS IT!

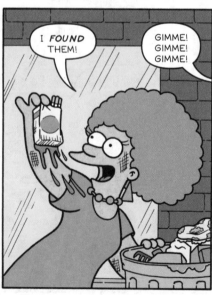

I **FOUND** THEM!

GIMME! GIMME! GIMME!

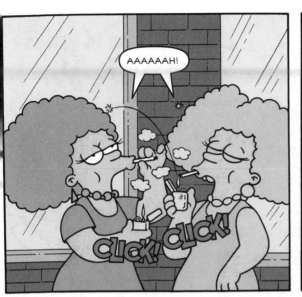
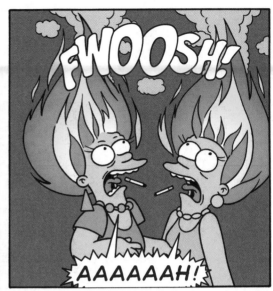
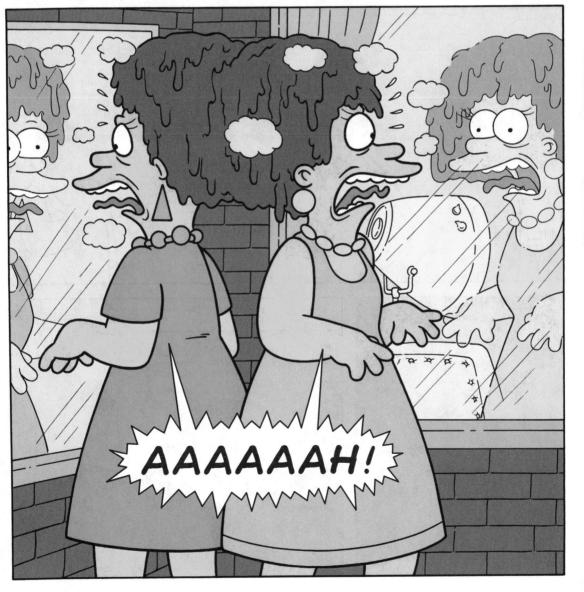

LATER...

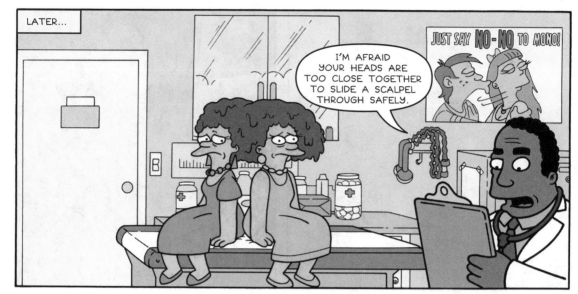

I'M AFRAID YOUR HEADS ARE TOO CLOSE TOGETHER TO SLIDE A SCALPEL THROUGH SAFELY.

JUST SAY NO-NO TO MONO!

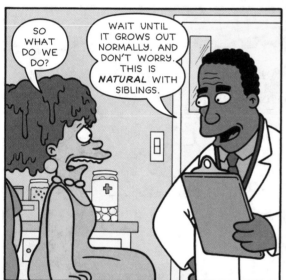

SO WHAT DO WE DO?

WAIT UNTIL IT GROWS OUT NORMALLY. AND DON'T WORRY. THIS IS *NATURAL* WITH SIBLINGS.

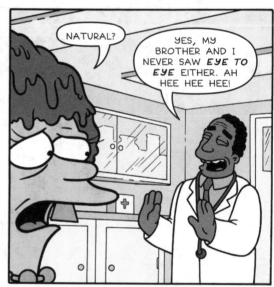

NATURAL?

YES, MY BROTHER AND I NEVER SAW *EYE TO EYE* EITHER. AH HEE HEE HEE!

ᴇSIGHᴇ

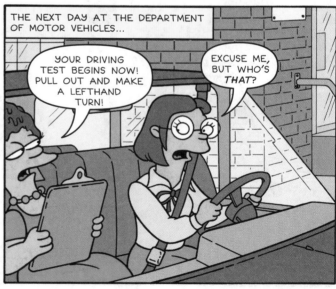

THE NEXT DAY AT THE DEPARTMENT OF MOTOR VEHICLES...

YOUR DRIVING TEST BEGINS NOW! PULL OUT AND MAKE A LEFTHAND TURN!

EXCUSE ME, BUT WHO'S *THAT*?

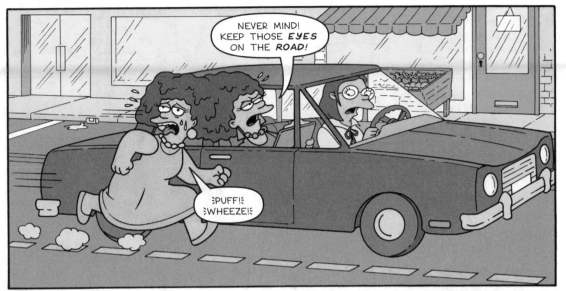

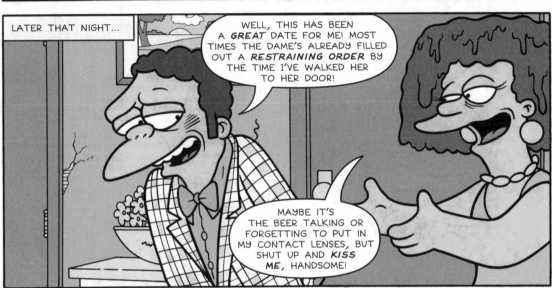

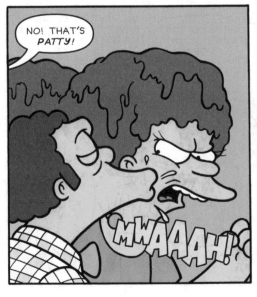

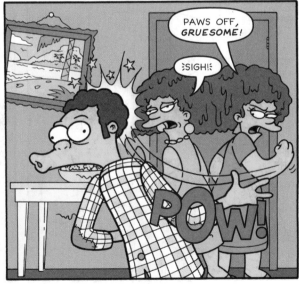

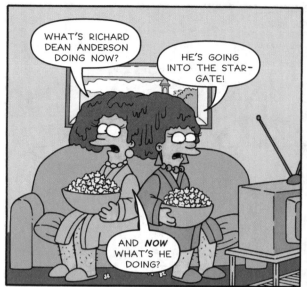

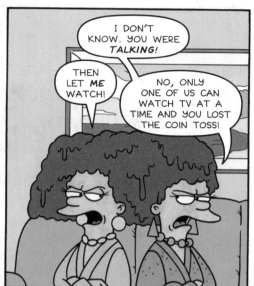

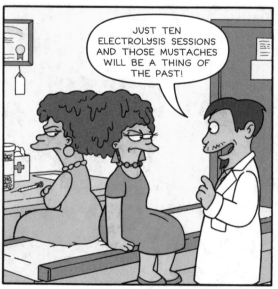

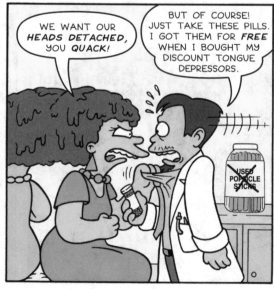

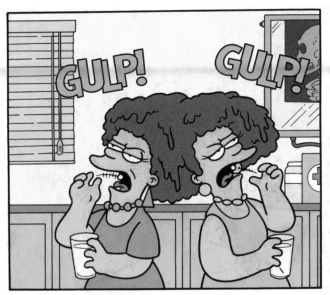

GULP! GULP!

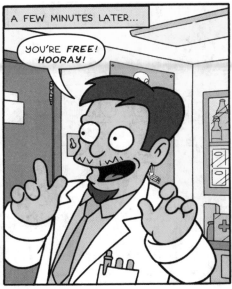

A FEW MINUTES LATER...

YOU'RE *FREE!* *HOORAY!*

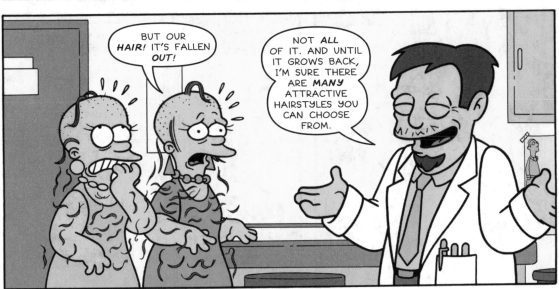

BUT OUR *HAIR!* IT'S FALLEN *OUT!*

NOT *ALL* OF IT. AND UNTIL IT GROWS BACK, I'M SURE THERE ARE *MANY* ATTRACTIVE HAIRSTYLES YOU CAN CHOOSE FROM.

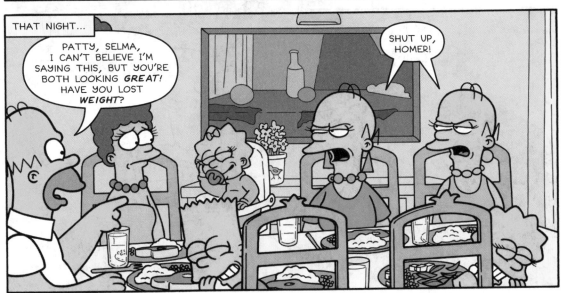

THAT NIGHT...

PATTY, SELMA, I CAN'T BELIEVE I'M SAYING THIS, BUT YOU'RE BOTH LOOKING *GREAT!* HAVE YOU LOST *WEIGHT?*

SHUT UP, HOMER!

COMIC BOOK GUY
GETS
A
LIFE!

THEN THERE WAS A PATIENT WHO I MET IN A CASE CALLED...

BIG ETHEL KILLS *MOOSE* TO GET *JUGHEAD'S* ATTENTION?

Archie DISASSEMBLED

OH, BRIAN MICHAEL BENDIS, YOU'VE DONE IT AGAIN!

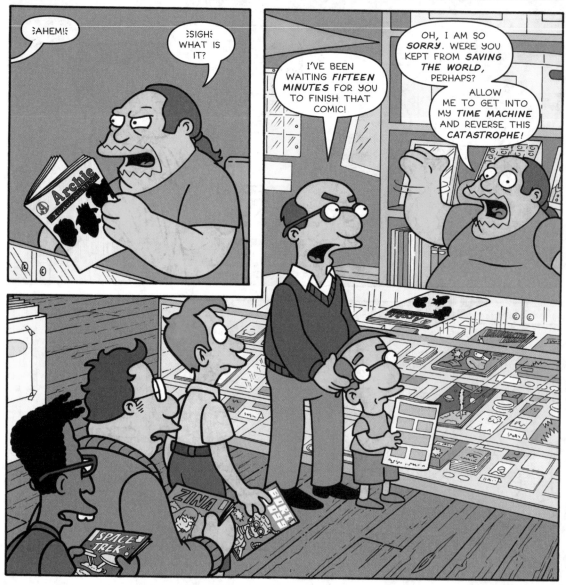

:AHEM!:

:SIGH: WHAT IS IT?

I'VE BEEN WAITING *FIFTEEN MINUTES* FOR YOU TO FINISH THAT COMIC!

OH, I AM SO *SORRY*. WERE YOU KEPT FROM *SAVING THE WORLD*, PERHAPS?

ALLOW ME TO GET INTO MY *TIME MACHINE* AND REVERSE THIS *CATASTROPHE!*

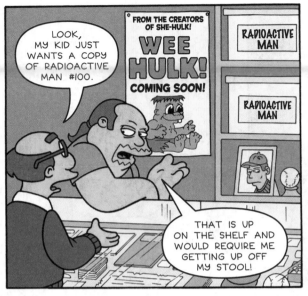

LOOK, MY KID JUST WANTS A COPY OF RADIOACTIVE MAN #100.

FROM THE CREATORS OF SHE-HULK! WEE HULK! COMING SOON!

RADIOACTIVE MAN

RADIOACTIVE MAN

THAT IS UP ON THE SHELF AND WOULD REQUIRE ME GETTING UP OFF MY STOOL!

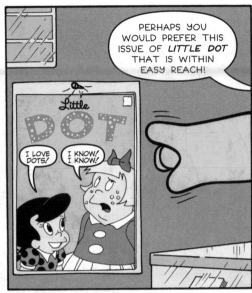

PERHAPS YOU WOULD PREFER THIS ISSUE OF *LITTLE DOT* THAT IS WITHIN EASY REACH!

Little DOT

I LOVE DOTS!

I KNOW! I KNOW!

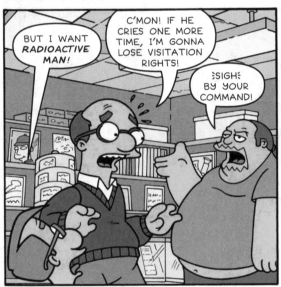

BUT I WANT *RADIOACTIVE MAN!*

C'MON! IF HE CRIES ONE MORE TIME, I'M GONNA LOSE VISITATION RIGHTS!

≈SIGH≈ BY YOUR COMMAND!

NOTHING LIKE *CUSTOMERS* TO RUIN A *GOOD STORE!*

RADIOACTIVE MAN

R M

RADIOACTIVE MAN

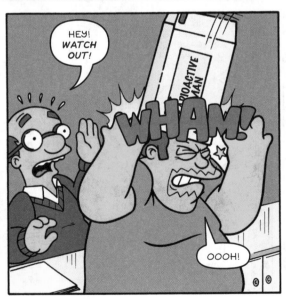

HEY! *WATCH OUT!*

WHAM!

OOOH!

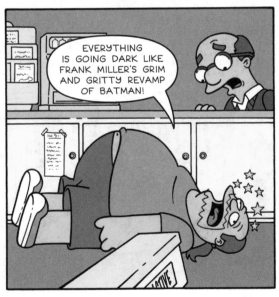

EVERYTHING IS GOING DARK LIKE FRANK MILLER'S GRIM AND GRITTY REVAMP OF BATMAN!

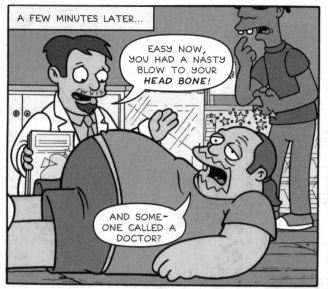

A FEW MINUTES LATER...

EASY NOW, YOU HAD A NASTY BLOW TO YOUR *HEAD BONE*!

AND SOMEONE CALLED A DOCTOR?

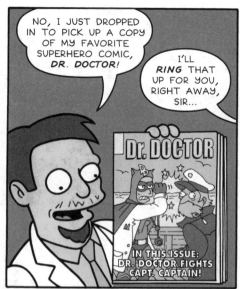

NO, I JUST DROPPED IN TO PICK UP A COPY OF MY FAVORITE SUPERHERO COMIC, *DR. DOCTOR*!

I'LL *RING* THAT UP FOR YOU, RIGHT AWAY, SIR...

Dr. DOCTOR

IN THIS ISSUE: DR. DOCTOR FIGHTS CAPT. CAPTAIN!

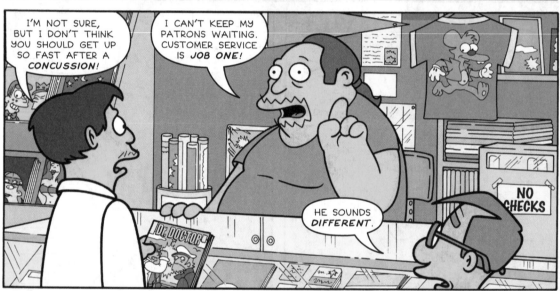

I'M NOT SURE, BUT I DON'T THINK YOU SHOULD GET UP SO FAST AFTER A *CONCUSSION*!

I CAN'T KEEP MY PATRONS WAITING. CUSTOMER SERVICE IS *JOB ONE*!

HE SOUNDS *DIFFERENT*.

NO CHECKS

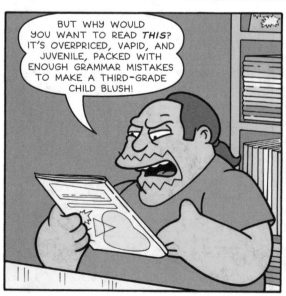

BUT WHY WOULD YOU WANT TO READ *THIS*? IT'S OVERPRICED, VAPID, AND JUVENILE, PACKED WITH ENOUGH GRAMMAR MISTAKES TO MAKE A THIRD-GRADE CHILD BLUSH!

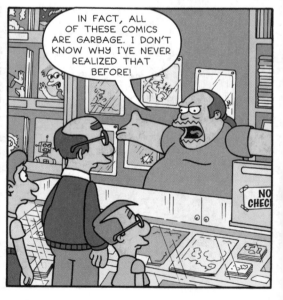

IN FACT, ALL OF THESE COMICS ARE GARBAGE. I DON'T KNOW WHY I'VE NEVER REALIZED THAT BEFORE!

NO CHEC

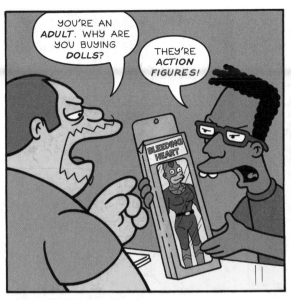

YOU'RE AN **ADULT**. WHY ARE YOU BUYING **DOLLS**?

THEY'RE **ACTION FIGURES**!

BLEEDING HEART

I THINK THE **NERD SECTION** OF YOUR BRAIN WAS DAMAGED IN THE ACCIDENT.

WILL I GO BACK TO THE WAY I **WAS**? ACTUALLY **LIKING** THIS **STUFF**?

NO, BRAIN CELLS DON'T GROW BACK, AS I LEARNED IN MY COLLEGE DORM THE **HARD** WAY. YOU'RE LIKE THIS FOREVER!

GIRL COM

GOOD! LOOK AT THIS PLACE! DO I EVEN **OWN** A BROOM? IT SMELLS LIKE **CAT WET**, AND I HAVEN'T OWNED A CAT FOR **TEN YEARS**!

AND LOOK AT **ME**. PEOPLE IN **COMAS** ARE IN BETTER **SHAPE**! I'VE WASTED THE TIME I WAS GIVEN ON THIS EARTH! **BUT NO MORE**!

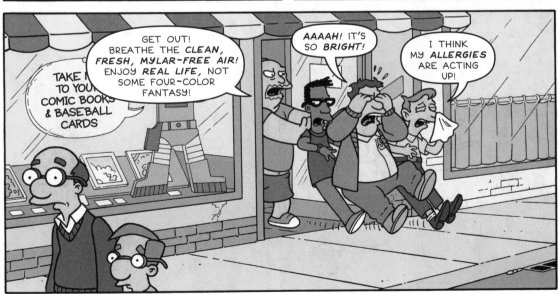

GET OUT! BREATHE THE **CLEAN, FRESH, MYLAR-FREE** AIR! ENJOY **REAL LIFE**, NOT SOME FOUR-COLOR FANTASY!

TAKE TO YOUR COMIC BOOKS & BASEBALL CARDS

AAAAH! IT'S SO **BRIGHT**!

I THINK MY **ALLERGIES** ARE ACTING UP!

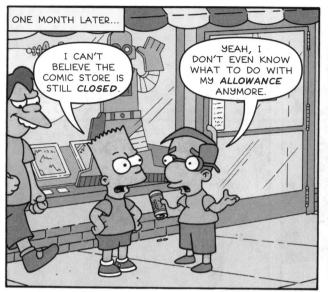

ONE MONTH LATER...

I CAN'T BELIEVE THE COMIC STORE IS STILL *CLOSED*.

YEAH, I DON'T EVEN KNOW WHAT TO DO WITH MY *ALLOWANCE* ANYMORE.

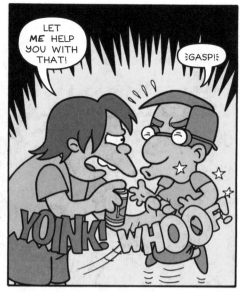

LET *ME* HELP YOU WITH THAT!

⁞GASP!⁞

YOINK! WHOO!

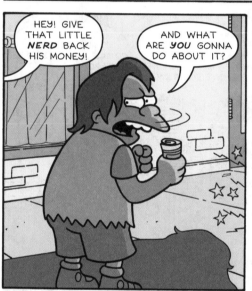

HEY! GIVE THAT LITTLE *NERD* BACK HIS MONEY!

AND WHAT ARE *YOU* GONNA DO ABOUT IT?

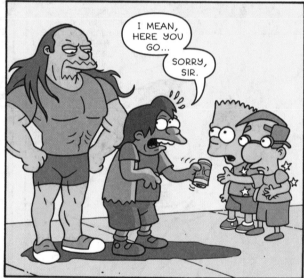

I MEAN, HERE YOU GO...

SORRY, SIR.

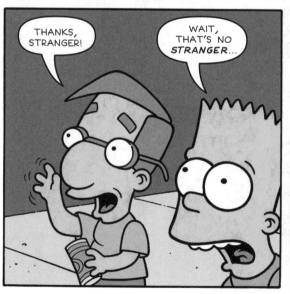

THANKS, STRANGER!

WAIT, THAT'S NO *STRANGER*...

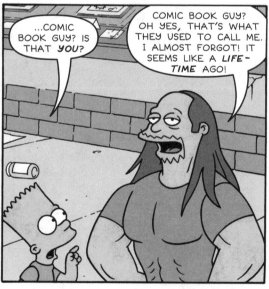

...COMIC BOOK GUY? IS THAT *YOU*?

COMIC BOOK GUY? OH YES, THAT'S WHAT THEY USED TO CALL ME. I ALMOST FORGOT! IT SEEMS LIKE A *LIFE-TIME* AGO!

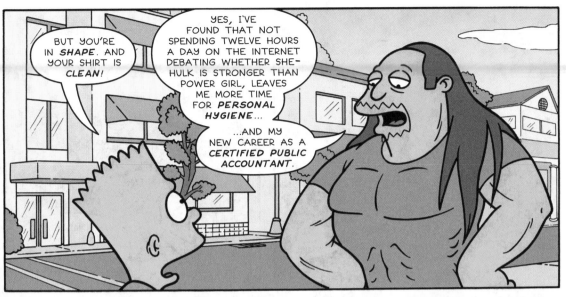

BUT YOU'RE IN *SHAPE*. AND YOUR SHIRT IS *CLEAN!*

YES, I'VE FOUND THAT NOT SPENDING TWELVE HOURS A DAY ON THE INTERNET DEBATING WHETHER SHE-HULK IS STRONGER THAN POWER GIRL, LEAVES ME MORE TIME FOR *PERSONAL HYGIENE*...

...AND MY NEW CAREER AS A *CERTIFIED PUBLIC ACCOUNTANT.*

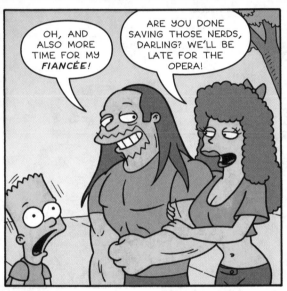

OH, AND ALSO MORE TIME FOR MY *FIANCÉE!*

ARE YOU DONE SAVING THOSE NERDS, DARLING? WE'LL BE LATE FOR THE OPERA!

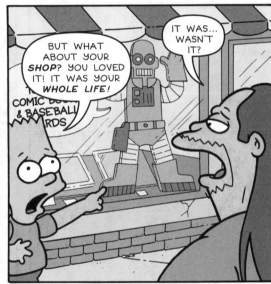

BUT WHAT ABOUT YOUR *SHOP?* YOU LOVED IT! IT WAS YOUR *WHOLE LIFE!*

IT WAS... WASN'T IT?

COMIC BOOKS & BASEBALL CARDS

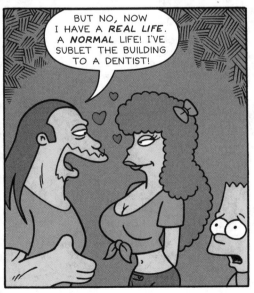

BUT NO, NOW I HAVE A *REAL LIFE*. A *NORMAL* LIFE! I'VE SUBLET THE BUILDING TO A DENTIST!

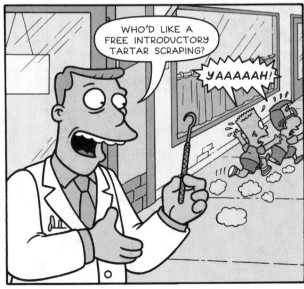

WHO'D LIKE A FREE INTRODUCTORY TARTAR SCRAPING?

YAAAAAH!

LATER...

SPRINGFIELD OPERA HOUSE

TONIGHT

NIBELUNG'S THE RING CYCLE

SPRINGFIELD TIRE YARD

≷SIGH≷

IS SOMETHING *WRONG*, DARLING? DIDN'T YOU ENJOY THE STORY OF *THE RING*?

IT'S JUST THAT *THIS* RING STORY DIDN'T BRING ME THE SAME JOY AS FRODO'S, GREEN LANTERN'S, OR EVEN THE 1969 ANIMATED SERIES "THE MIGHTY HERCULES."

I...I THINK I NEED TO BE ALONE FOR A WHILE.

≷SIGH!≷

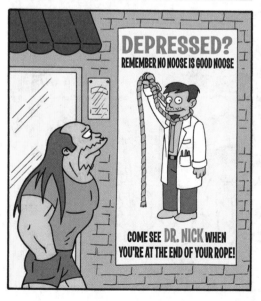

DEPRESSED?

REMEMBER NO NOOSE IS GOOD NOOSE

COME SEE DR. NICK WHEN YOU'RE AT THE END OF YOUR ROPE!

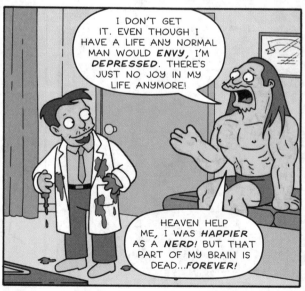

I DON'T GET IT. EVEN THOUGH I HAVE A LIFE ANY NORMAL MAN WOULD *ENVY*, I'M *DEPRESSED*. THERE'S JUST NO JOY IN MY LIFE ANYMORE!

HEAVEN HELP ME, I WAS *HAPPIER* AS A *NERD*! BUT THAT PART OF MY BRAIN IS DEAD...*FOREVER!*

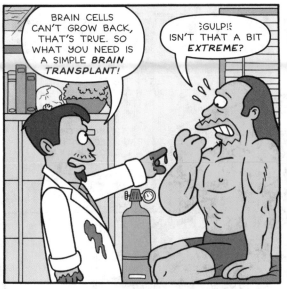

BRAIN CELLS CAN'T GROW BACK, THAT'S TRUE. SO WHAT YOU NEED IS A SIMPLE *BRAIN TRANSPLANT!*

≀GULP!≀ ISN'T THAT A BIT *EXTREME?*

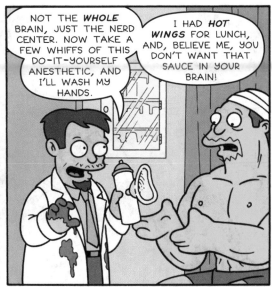

NOT THE *WHOLE* BRAIN, JUST THE NERD CENTER. NOW TAKE A FEW WHIFFS OF THIS DO-IT-YOURSELF ANESTHETIC, AND I'LL WASH MY HANDS.

I HAD *HOT WINGS* FOR LUNCH, AND, BELIEVE ME, YOU DON'T WANT THAT SAUCE IN YOUR BRAIN!

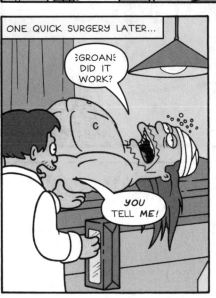

ONE QUICK SURGERY LATER...

≀GROAN≀ DID IT WORK?

YOU TELL *ME!*

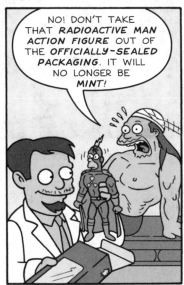

NO! DON'T TAKE THAT *RADIOACTIVE MAN ACTION FIGURE* OUT OF THE *OFFICIALLY-SEALED PACKAGING.* IT WILL NO LONGER BE *MINT!*

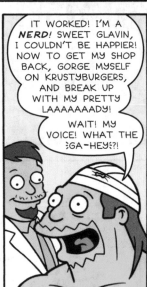

IT WORKED! I'M A *NERD!* SWEET GLAVIN, I COULDN'T BE HAPPIER! NOW TO GET MY SHOP BACK, GORGE MYSELF ON KRUSTYBURGERS, AND BREAK UP WITH MY PRETTY LAAAAAAADY!

WAIT! MY VOICE! WHAT THE ≀GA-HEY≀?!

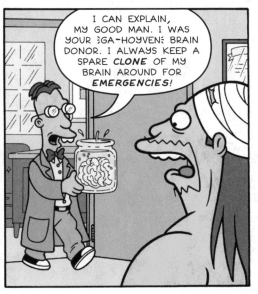

I CAN EXPLAIN, MY GOOD MAN. I WAS YOUR ≀GA-HOYVEN≀ BRAIN DONOR. I ALWAYS KEEP A SPARE *CLONE* OF MY BRAIN AROUND FOR *EMERGENCIES!*

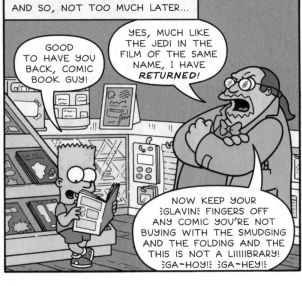

AND SO, NOT TOO MUCH LATER...

GOOD TO HAVE YOU BACK, COMIC BOOK GUY!

YES, MUCH LIKE THE JEDI IN THE FILM OF THE SAME NAME, I HAVE *RETURNED!*

NOW KEEP YOUR ≀GLAVIN≀ FINGERS OFF ANY COMIC YOU'RE NOT BUYING WITH THE SMUDGING AND THE FOLDING AND THE THIS IS NOT A LIIIIBRARY! ≀GA-HOY!≀ ≀GA-HEY!≀

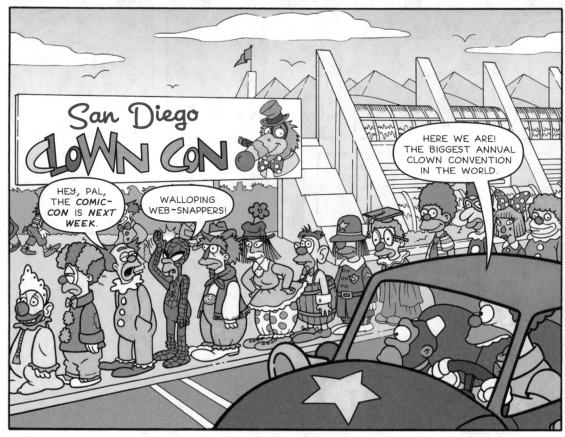

CHECK IT OUT, MR. TEENY! ALL THE LATEST INNOVATIONS IN *CLOWN TECHNOLOGY!*

LASER GUIDED SELTZER

CLOWN RHINOPLASTY FOR A PERMANENT RED NOSE

FLEU DE SQU

ERGONOMICALLY BALANCED THROWING PIES PREVENTS CARPAL TUN...

EEEK! EEEK!

BORING?!! YOU KNOW I'VE HAD JUST ABOUT ENOUGH OF YOUR *BELLYACHING!* YOU'RE *FIRED!*

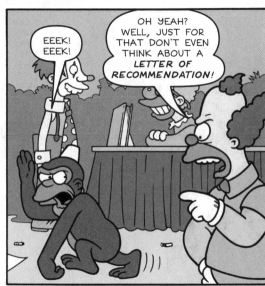

EEEK! EEEK!

OH YEAH? WELL, JUST FOR THAT DON'T EVEN THINK ABOUT A *LETTER OF RECOMMENDATION!*

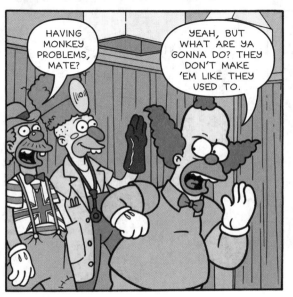

HAVING MONKEY PROBLEMS, MATE?

YEAH, BUT WHAT ARE YA GONNA DO? THEY DON'T MAKE 'EM LIKE THEY USED TO.

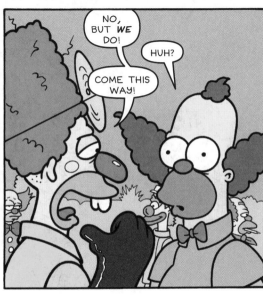

NO, BUT *WE* DO!

HUH?

COME THIS WAY!

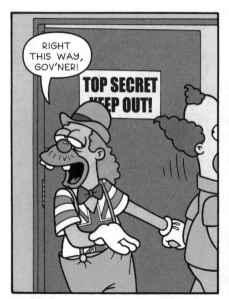

RIGHT THIS WAY, GOV'NER!

TOP SECRET KEEP OUT!

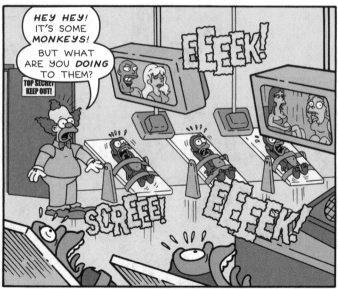

HEY HEY! IT'S SOME *MONKEYS!*

BUT WHAT ARE YOU *DOING* TO THEM?

TOP SECRET KEEP OUT!

EEEEK!

SCREEE!

EEEEK!

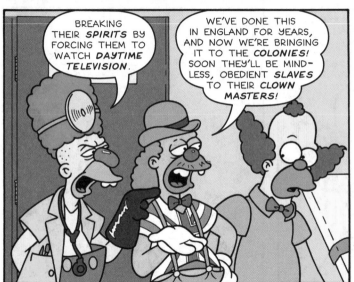

BREAKING THEIR *SPIRITS* BY FORCING THEM TO WATCH *DAYTIME TELEVISION*.

WE'VE DONE THIS IN ENGLAND FOR YEARS, AND NOW WE'RE BRINGING IT TO THE *COLONIES!* SOON THEY'LL BE MINDLESS, OBEDIENT *SLAVES* TO THEIR *CLOWN MASTERS!*

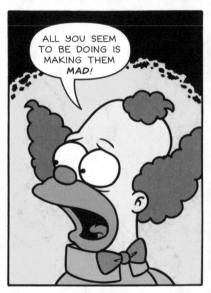

ALL YOU SEEM TO BE DOING IS MAKING THEM *MAD!*

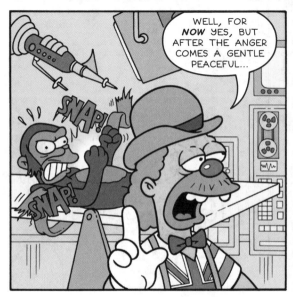

WELL, FOR *NOW* YES, BUT AFTER THE ANGER COMES A GENTLE PEACEFUL...

SNAP!

SNAP!

CHOMP!

OH! I *SAY!*

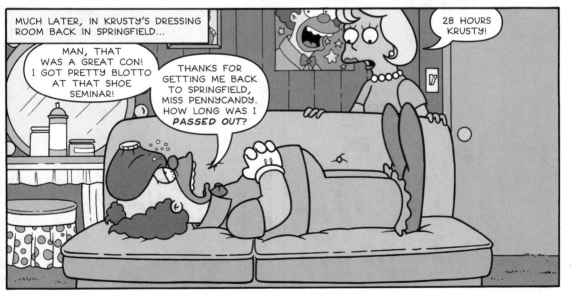

ANYTHING INTERESTING HAPPEN WHILE I WAS OUT?

WELL...

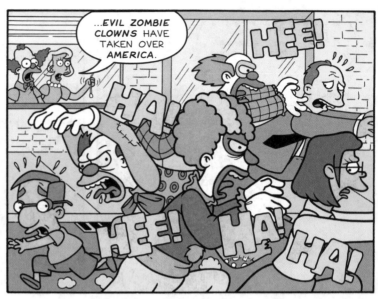

...EVIL ZOMBIE CLOWNS HAVE TAKEN OVER AMERICA.

HEE!

HA!

HEE!

HA!

HA!

WHAT THE--?!

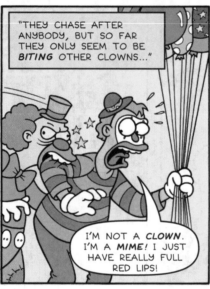

"THEY CHASE AFTER ANYBODY, BUT SO FAR THEY ONLY SEEM TO BE BITING OTHER CLOWNS..."

I'M NOT A CLOWN. I'M A MIME! I JUST HAVE REALLY FULL RED LIPS!

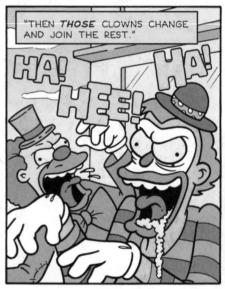

"THEN THOSE CLOWNS CHANGE AND JOIN THE REST."

HA!

HEE!

HA!

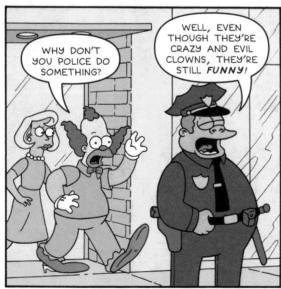

WHY DON'T YOU POLICE DO SOMETHING?

WELL, EVEN THOUGH THEY'RE CRAZY AND EVIL CLOWNS, THEY'RE STILL FUNNY!

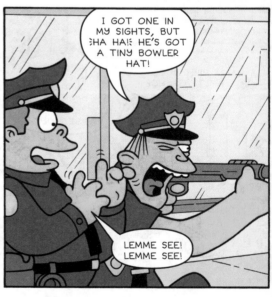

I GOT ONE IN MY SIGHTS, BUT ¡HA HA!¡ HE'S GOT A TINY BOWLER HAT!

LEMME SEE! LEMME SEE!

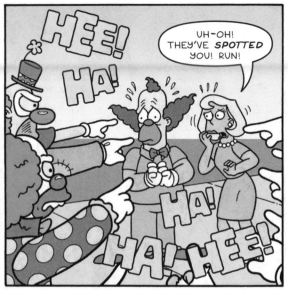

HEE! HA! HA! HEE!

UH-OH! THEY'VE **SPOTTED** YOU! RUN!

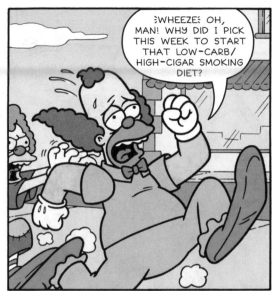

≷WHEEZE≷ OH, MAN! WHY DID I PICK THIS WEEK TO START THAT LOW-CARB/HIGH-CIGAR SMOKING DIET?

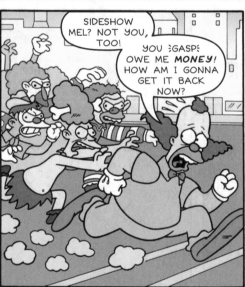

SIDESHOW MEL? NOT YOU, TOO!

YOU ≷GASP≷ OWE ME **MONEY**! HOW AM I GONNA GET IT BACK NOW?

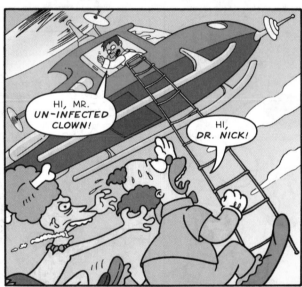

HI, MR. **UN-INFECTED** CLOWN!

HI, **DR. NICK!**

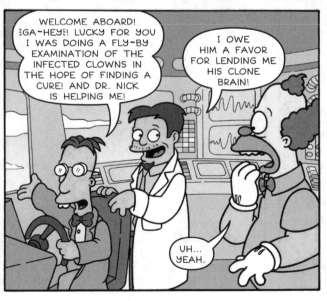

WELCOME ABOARD! ≷GA-HEY!≷ LUCKY FOR YOU I WAS DOING A FLY-BY EXAMINATION OF THE INFECTED CLOWNS IN THE HOPE OF FINDING A CURE! AND DR. NICK IS HELPING ME!

I OWE HIM A FAVOR FOR LENDING ME HIS CLONE BRAIN!

UH... YEAH.

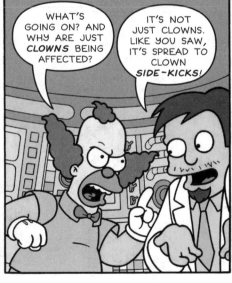

WHAT'S GOING ON? AND WHY ARE JUST **CLOWNS** BEING AFFECTED?

IT'S NOT JUST CLOWNS. LIKE YOU SAW, IT'S SPREAD TO CLOWN **SIDE-KICKS!**

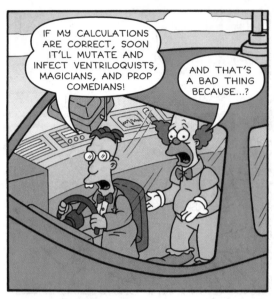

IF MY CALCULATIONS ARE CORRECT, SOON IT'LL MUTATE AND INFECT VENTRILOQUISTS, MAGICIANS, AND PROP COMEDIANS!

AND THAT'S A BAD THING BECAUSE...?

FROM THERE IT WILL SPREAD TO DECENT, NORMAL, NON-SHOWBIZ PEOPLE, DESTROYING ALL OF CIVILIZATION! AND THAT WOULD BE BAD FOR MY BUSINESS!

IF ONLY WE KNEW WHAT THE CLOWNS WERE EXPOSED TO. MAYBE SOMEONE WAS BITTEN OR...

BITTEN? DOC! I THINK I KNOW WHAT HAPPENED.

A QUICK RECAP LATER...

WHAT HORRIBLE BRITISH MONKEY-BASED FRANKENSTEIN-ERY! EUROPE ALWAYS HAS THE BEST *MAD SCIENTISTS*, NO MATTER HOW HARD WE TRY TO COMPETE! ⸘GA-HEY!⸘

BUT HOW DO WE REVERSE AN ANGRY MONKEY BITE VIRUS?

HOW ABOUT A BITE FROM A *HAPPY* MONKEY?

THAT'S *NUTS!* AND BESIDES, WHERE ARE WE GONNA FIND A *HAPPY* MONKEY?

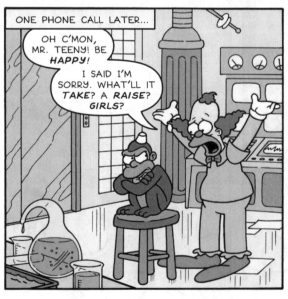

ONE PHONE CALL LATER...

OH C'MON, MR. TEENY! BE *HAPPY!*

I SAID I'M SORRY. WHAT'LL IT *TAKE?* A *RAISE?* GIRLS?

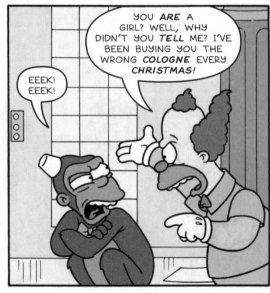

YOU *ARE* A GIRL? WELL, WHY DIDN'T YOU *TELL* ME? I'VE BEEN BUYING YOU THE WRONG *COLOGNE* EVERY *CHRISTMAS!*

EEEK! EEEK!

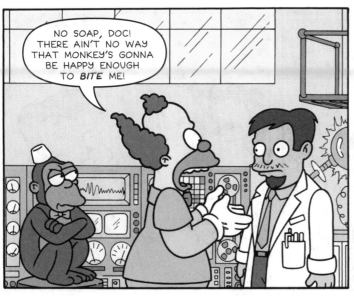

NO SOAP, DOC! THERE AIN'T NO WAY THAT MONKEY'S GONNA BE HAPPY ENOUGH TO *BITE* ME!

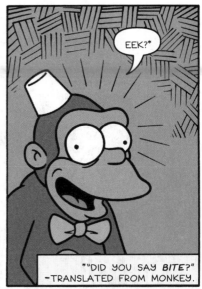

EEK?*

*"DID YOU SAY *BITE*?" —TRANSLATED FROM MONKEY.

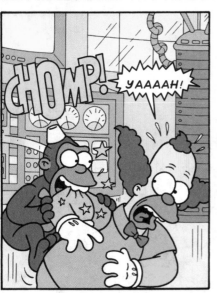

CHOMP!

YAAAAH!

AND SO, FOR THE NEXT FEW HOURS....

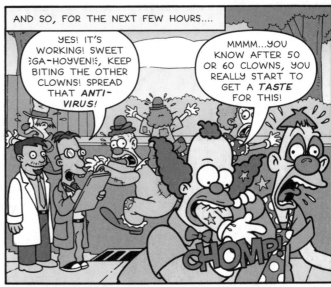

YES! IT'S WORKING! SWEET GA-HOYVEN!, KEEP BITING THE OTHER CLOWNS! SPREAD THAT *ANTI-VIRUS*!

MMMM...YOU KNOW AFTER 50 OR 60 CLOWNS, YOU REALLY START TO GET A *TASTE* FOR THIS!

CHOMP!

WHICH BRINGS US BACK TO THE GYMNASIUM...

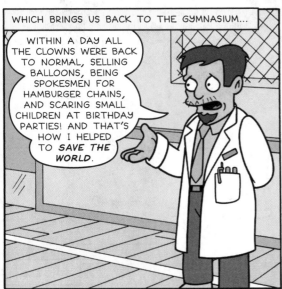

WITHIN A DAY ALL THE CLOWNS WERE BACK TO NORMAL, SELLING BALLOONS, BEING SPOKESMEN FOR HAMBURGER CHAINS, AND SCARING SMALL CHILDREN AT BIRTHDAY PARTIES! AND THAT'S HOW I HELPED TO *SAVE THE WORLD*.

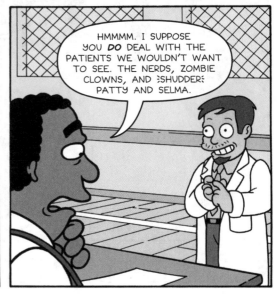

HMMMM. I SUPPOSE YOU *DO* DEAL WITH THE PATIENTS WE WOULDN'T WANT TO SEE. THE NERDS, ZOMBIE CLOWNS, AND ≥SHUDDER≤ PATTY AND SELMA.

FINE! YOU CAN KEEP PRACTICING MEDICINE, BUT STOP MOONLIGHTING AS A *VETERINARIAN* ON THE SIDE.

I DON'T KNOW...

OKAY, AT LEAST WHEN YOU DO *TRANSPLANTS* USE BODY PARTS FROM THE SAME *SPECIES* OF *ANIMAL!*

SCOUT'S HONOR!

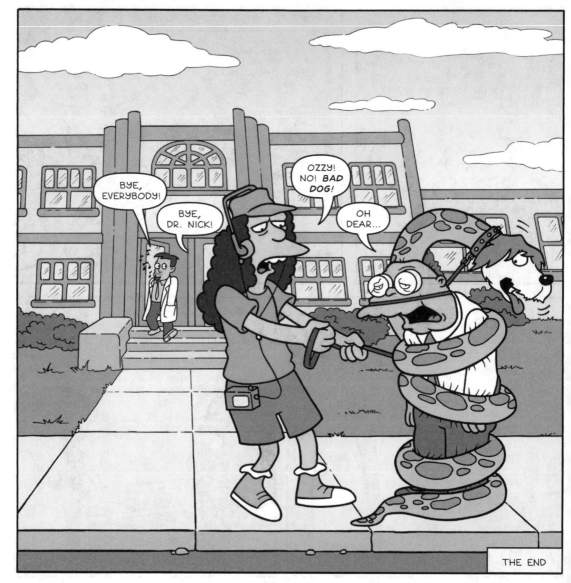

BYE, EVERYBODY!

BYE, DR. NICK!

OZZY! NO! *BAD DOG!*

OH DEAR...

THE END

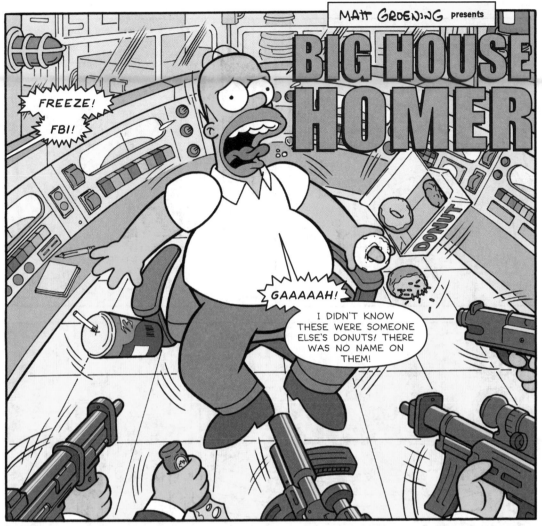

MATT GROENING presents

BIG HOUSE HOMER

FREEZE!

FBI!

GAAAAAH!

I DIDN'T KNOW THESE WERE SOMEONE ELSE'S DONUTS! THERE WAS NO NAME ON THEM!

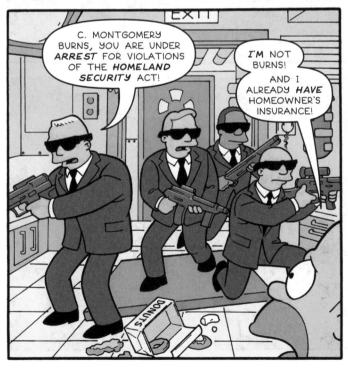

C. MONTGOMERY BURNS, YOU ARE UNDER **ARREST** FOR VIOLATIONS OF THE **HOMELAND SECURITY** ACT!

I'M NOT BURNS!

AND I ALREADY **HAVE** HOMEOWNER'S INSURANCE!

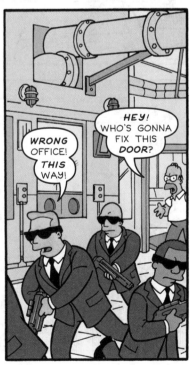

WRONG OFFICE! **THIS** WAY!

HEY! WHO'S GONNA FIX THIS **DOOR?**

MEANWHILE, IN THE EXECUTIVE SPA...

YOUR BATH IS **DRAWN**, SIR.

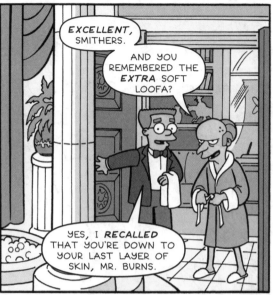

EXCELLENT, SMITHERS.

AND YOU REMEMBERED THE **EXTRA** SOFT LOOFA?

YES, I **RECALLED** THAT YOU'RE DOWN TO YOUR LAST LAYER OF SKIN, MR. BURNS.

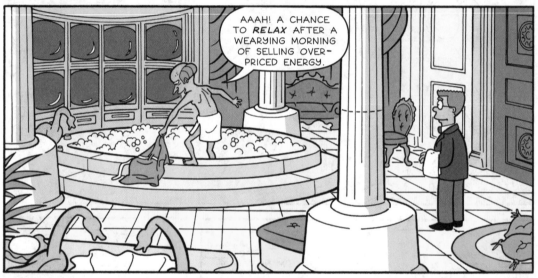

AAAH! A CHANCE TO **RELAX** AFTER A WEARYING MORNING OF SELLING OVER-PRICED ENERGY.

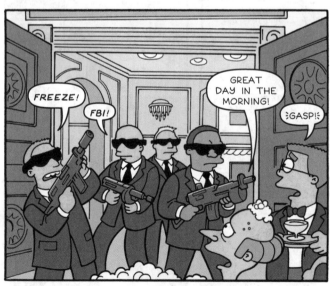

FREEZE!

FBI!

GREAT DAY IN THE MORNING!

:GASP!:

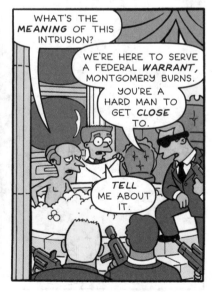

WHAT'S THE **MEANING** OF THIS INTRUSION?

WE'RE HERE TO SERVE A FEDERAL **WARRANT**, MONTGOMERY BURNS.

YOU'RE A HARD MAN TO GET **CLOSE** TO.

TELL ME ABOUT IT.

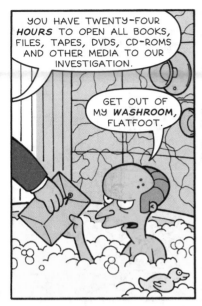

YOU HAVE TWENTY-FOUR *HOURS* TO OPEN ALL BOOKS, FILES, TAPES, DVDS, CD-ROMS AND OTHER MEDIA TO OUR INVESTIGATION.

GET OUT OF MY *WASHROOM*, FLATFOOT.

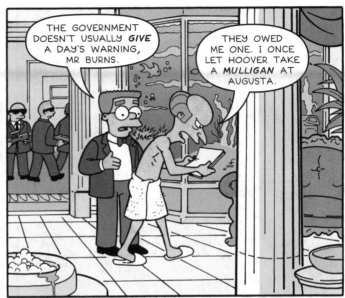

THE GOVERNMENT DOESN'T USUALLY *GIVE* A DAY'S WARNING, MR BURNS.

THEY OWED ME ONE. I ONCE LET HOOVER TAKE A *MULLIGAN* AT AUGUSTA.

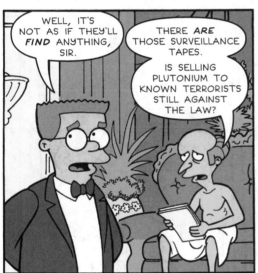

WELL, IT'S NOT AS IF THEY'LL *FIND* ANYTHING, SIR.

THERE *ARE* THOSE SURVEILLANCE TAPES.

IS SELLING PLUTONIUM TO KNOWN TERRORISTS STILL AGAINST THE LAW?

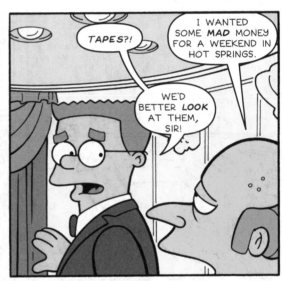

TAPES?!

I WANTED SOME *MAD* MONEY FOR A WEEKEND IN HOT SPRINGS.

WE'D BETTER *LOOK* AT THEM, SIR!

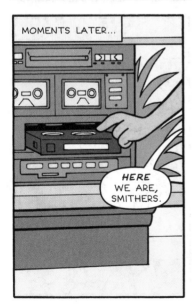

MOMENTS LATER...

HERE WE ARE, SMITHERS.

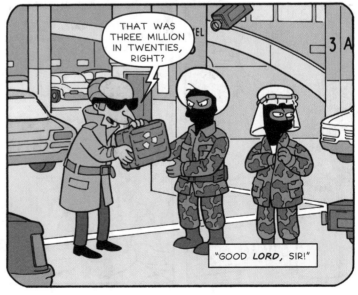

THAT WAS THREE MILLION IN TWENTIES, RIGHT?

"GOOD *LORD*, SIR!"

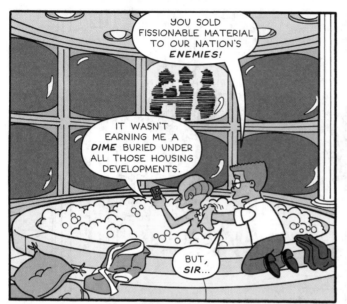

YOU SOLD FISSIONABLE MATERIAL TO OUR NATION'S *ENEMIES!*

IT WASN'T EARNING ME A *DIME* BURIED UNDER ALL THOSE HOUSING DEVELOPMENTS.

BUT, *SIR...*

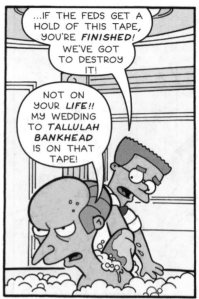

...IF THE FEDS GET A HOLD OF THIS TAPE, YOU'RE *FINISHED!* WE'VE GOT TO DESTROY IT!

NOT ON YOUR *LIFE!!* MY WEDDING TO *TALLULAH BANKHEAD* IS ON THAT TAPE!

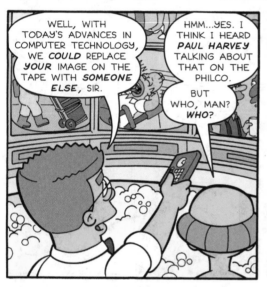

WELL, WITH TODAY'S ADVANCES IN COMPUTER TECHNOLOGY, WE *COULD* REPLACE *YOUR* IMAGE ON THE TAPE WITH *SOMEONE ELSE*, SIR.

HMM...YES. I THINK I HEARD *PAUL HARVEY* TALKING ABOUT THAT ON THE PHILCO. BUT WHO, MAN? *WHO?*

SOMEONE PICKED ENTIRELY AT RANDOM... SOME WORTHLESS, LAZY, TROUBLESOME, *RANDOMLY CHOSEN* NOBODY.

WELL, THERE'S NO EMPLOYEE MORE WORTHLESS THAN HOMER SIMPSON.

OF COURSE, HE'LL BE BRANDED A *TRAITOR* AND PUT AWAY IN *FEDERAL PRISON* FOREVER.

HIS LIFE AND THAT OF HIS FAMILY WOULD BE UTTERLY, UTTERLY *DESTROYED*.

THAT'S A RATHER STEEP PENALTY JUST FOR BEING A BAD EMPLOYEE.

ENOUGH! YOU'VE ALREADY SOLD ME, SMITHERS! LET'S BEGIN THE RUINATION OF HAGAR SAMPSON, POST HASTE!

SQUEEK

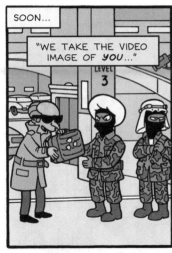

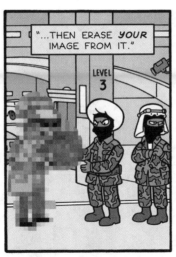

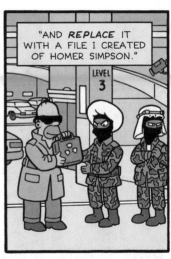

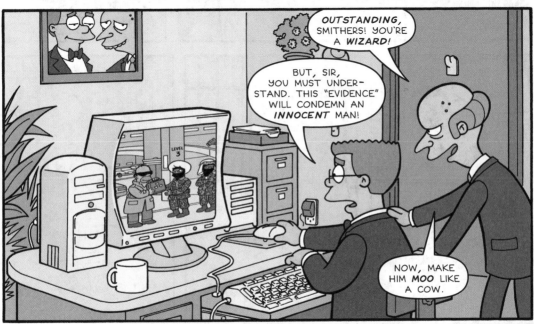

ITCHY & SCRATCHY in THE SHAWSHANK CONNIPTION

HEE HEE HEE!

RRORRWWW!

UH-OH!

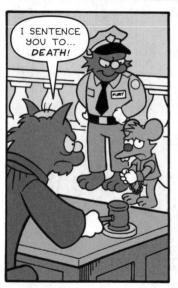

I SENTENCE YOU TO... DEATH!

FURY

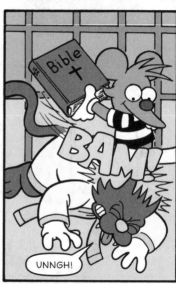

Bible

BAM!

UNNGH!

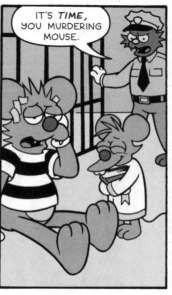

IT'S TIME, YOU MURDERING MOUSE.

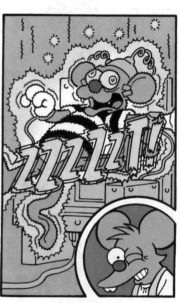

ZZZZZT!

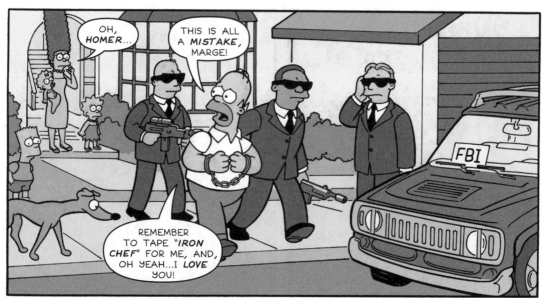

OH, *HOMER...*

THIS IS ALL A *MISTAKE,* MARGE!

REMEMBER TO TAPE *"IRON CHEF"* FOR ME, AND, OH YEAH...I *LOVE* YOU!

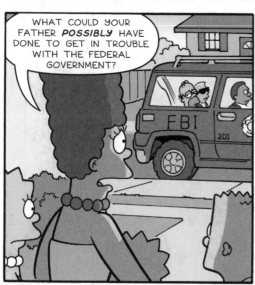

WHAT COULD YOUR FATHER *POSSIBLY* HAVE DONE TO GET IN TROUBLE WITH THE FEDERAL GOVERNMENT?

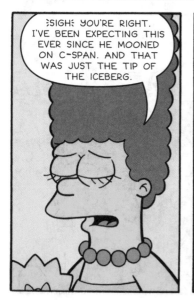

‹SIGH› YOU'RE RIGHT. I'VE BEEN EXPECTING THIS EVER SINCE HE MOONED ON C-SPAN. AND THAT WAS JUST THE TIP OF THE ICEBERG.

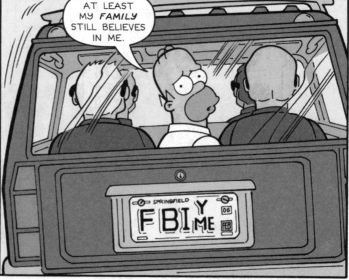

AT LEAST MY *FAMILY* STILL BELIEVES IN ME.

SPRINGFIELD
FBI ME

SEVERAL WEEKS LATER...

LADIES AND GENTLEMEN OF THE JURY...

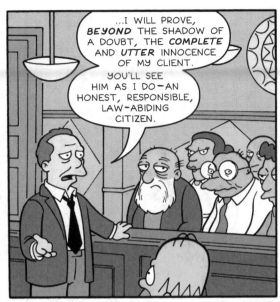

...I WILL PROVE, *BEYOND* THE SHADOW OF A DOUBT, THE *COMPLETE* AND *UTTER* INNOCENCE OF MY CLIENT.

YOU'LL SEE HIM AS I DO—AN HONEST, RESPONSIBLE, LAW-ABIDING CITIZEN.

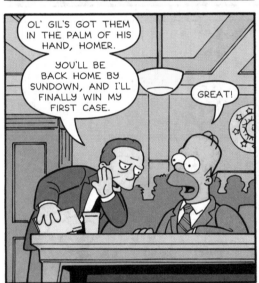

OL' GIL'S GOT THEM IN THE PALM OF HIS HAND, HOMER.

YOU'LL BE BACK HOME BY SUNDOWN, AND I'LL FINALLY WIN MY FIRST CASE.

GREAT!

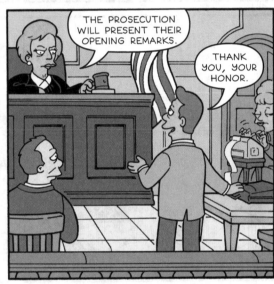

THE PROSECUTION WILL PRESENT THEIR OPENING REMARKS.

THANK YOU, YOUR HONOR.

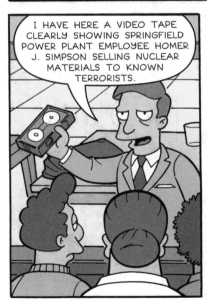

I HAVE HERE A VIDEO TAPE CLEARLY SHOWING SPRINGFIELD POWER PLANT EMPLOYEE HOMER J. SIMPSON SELLING NUCLEAR MATERIALS TO KNOWN TERRORISTS.

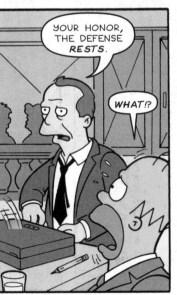

YOUR HONOR, THE DEFENSE *RESTS*.

WHAT!?

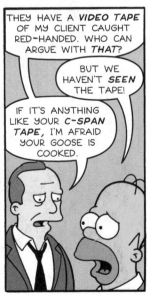

THEY HAVE A *VIDEO TAPE* OF MY CLIENT CAUGHT RED-HANDED. WHO CAN ARGUE WITH *THAT*?

BUT WE HAVEN'T *SEEN* THE TAPE!

IF IT'S ANYTHING LIKE YOUR *C-SPAN TAPE*, I'M AFRAID YOUR GOOSE IS COOKED.

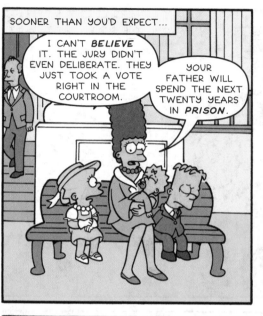

SOONER THAN YOU'D EXPECT...

I CAN'T *BELIEVE* IT. THE JURY DIDN'T EVEN DELIBERATE. THEY JUST TOOK A VOTE RIGHT IN THE COURTROOM.

YOUR FATHER WILL SPEND THE NEXT TWENTY YEARS IN *PRISON*.

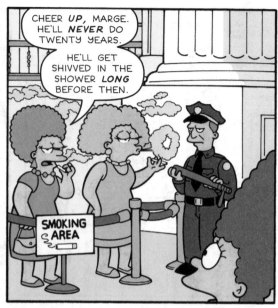

CHEER *UP*, MARGE. HE'LL *NEVER* DO TWENTY YEARS.

HE'LL GET SHIVVED IN THE SHOWER *LONG* BEFORE THEN.

SMOKING AREA

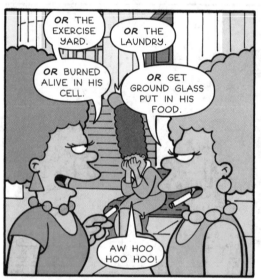

OR THE EXERCISE YARD.

OR THE LAUNDRY.

OR BURNED ALIVE IN HIS CELL.

OR GET GROUND GLASS PUT IN HIS FOOD.

AW HOO HOO HOO!

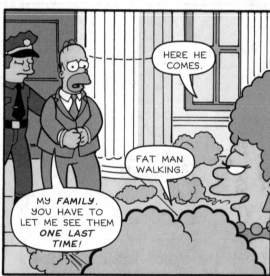

HERE HE COMES.

FAT MAN WALKING.

MY *FAMILY*. YOU HAVE TO LET ME SEE THEM *ONE LAST TIME*!

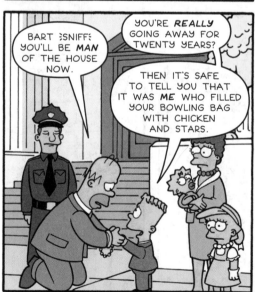

BART ;SNIFF; YOU'LL BE *MAN* OF THE HOUSE NOW.

YOU'RE *REALLY* GOING AWAY FOR TWENTY YEARS?

THEN IT'S SAFE TO TELL YOU THAT IT WAS *ME* WHO FILLED YOUR BOWLING BAG WITH CHICKEN AND STARS.

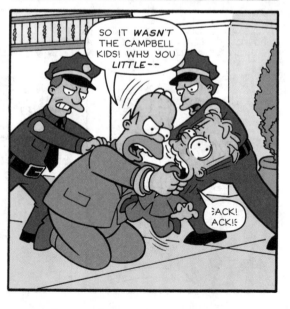

SO IT *WASN'T* THE CAMPBELL KIDS! WHY YOU *LITTLE--*

;ACK! ACK!;

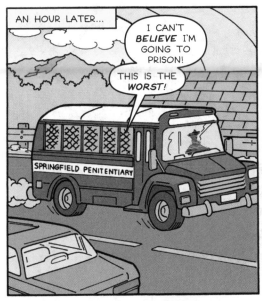

AN HOUR LATER...

I CAN'T *BELIEVE* I'M GOING TO PRISON!

THIS IS THE *WORST!*

SPRINGFIELD PENITENTIARY

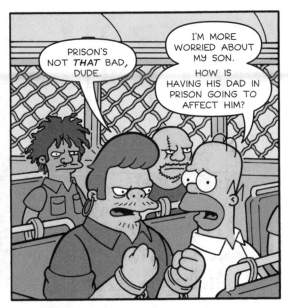

PRISON'S NOT *THAT* BAD, DUDE.

I'M MORE WORRIED ABOUT MY SON.

HOW IS HAVING HIS DAD IN PRISON GOING TO AFFECT HIM?

AT THAT VERY MOMENT...

HEY, *SIMPSON!*

UH-OH.

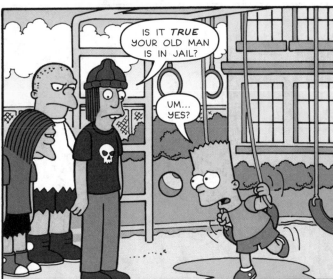

IS IT *TRUE* YOUR OLD MAN IS IN JAIL?

UM... YES?

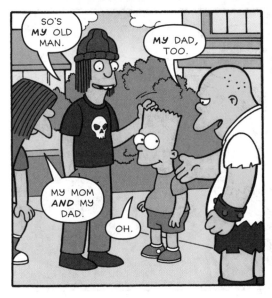

SO'S *MY* OLD MAN.

MY DAD, TOO.

MY MOM *AND* MY DAD.

OH.

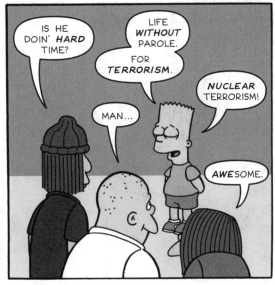

IS HE DOIN' *HARD* TIME?

LIFE *WITHOUT* PAROLE.

FOR *TERRORISM.*

MAN...

NUCLEAR TERRORISM!

AWESOME.

"SIMPSON, HOMER J."

"STAND *BEHIND* THE YELLOW LINE."

STOP

ABANDON SHIVS ALL YE WHO ENTER HERE

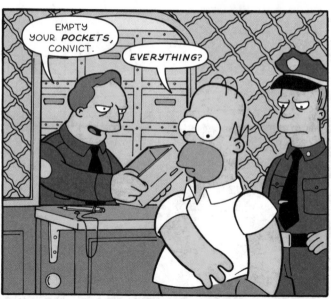

EMPTY YOUR *POCKETS*, CONVICT.

EVERYTHING?

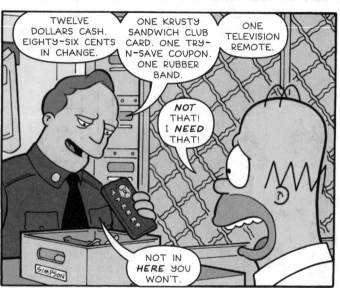

TWELVE DOLLARS CASH. EIGHTY-SIX CENTS IN CHANGE.

ONE KRUSTY SANDWICH CLUB CARD. ONE TRY-N-SAVE COUPON. ONE RUBBER BAND.

ONE TELEVISION REMOTE.

NOT THAT! I *NEED* THAT!

NOT IN *HERE* YOU WON'T.

WHY ME?

WH-HY-HY MEEEE?!?

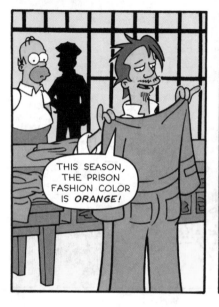

THIS SEASON, THE PRISON FASHION COLOR IS *ORANGE!*

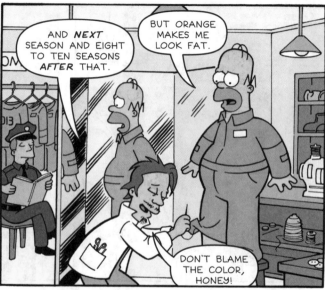

AND *NEXT* SEASON AND EIGHT TO TEN SEASONS *AFTER* THAT.

BUT ORANGE MAKES ME LOOK FAT.

DON'T BLAME THE COLOR, HONEY!

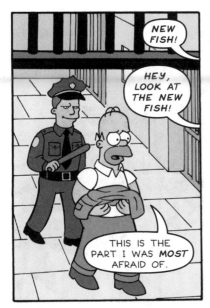

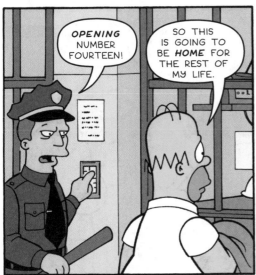

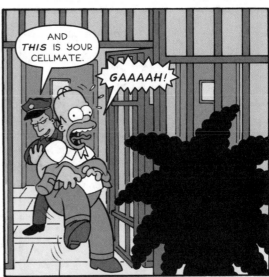

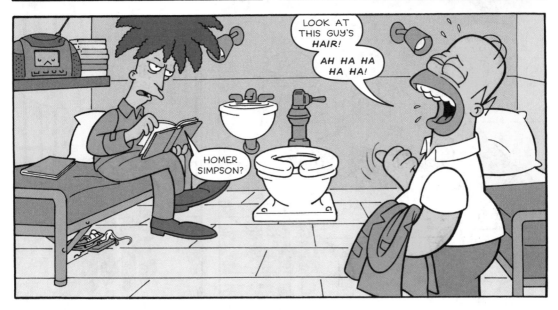

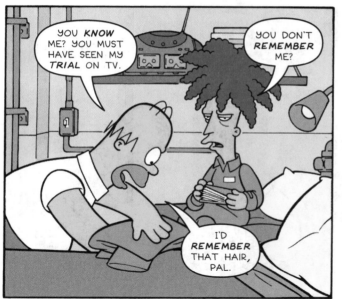

YOU *KNOW* ME? YOU MUST HAVE SEEN MY *TRIAL* ON TV.

YOU DON'T *REMEMBER* ME?

I'D *REMEMBER* THAT HAIR, PAL.

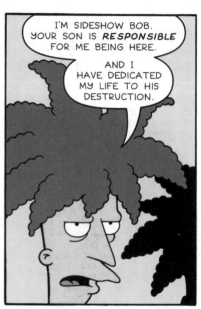

I'M SIDESHOW BOB. YOUR SON IS *RESPONSIBLE* FOR ME BEING HERE.

AND I HAVE DEDICATED MY LIFE TO HIS DESTRUCTION.

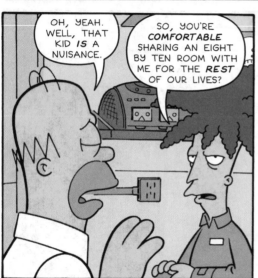

OH, YEAH. WELL, THAT KID *IS* A NUISANCE.

SO, YOU'RE *COMFORTABLE* SHARING AN EIGHT BY TEN ROOM WITH ME FOR THE *REST* OF OUR LIVES?

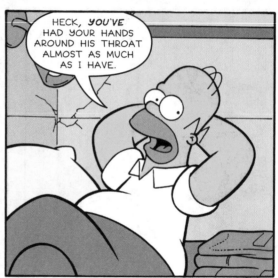

HECK, *YOU'VE* HAD YOUR HANDS AROUND HIS THROAT ALMOST AS MUCH AS I HAVE.

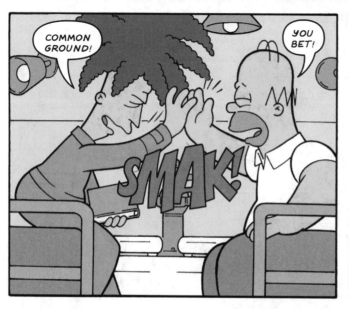

COMMON GROUND!

YOU BET!

SMAK!

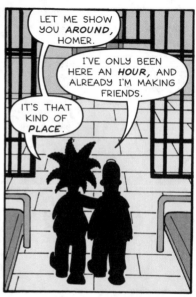

LET ME SHOW YOU *AROUND,* HOMER.

I'VE ONLY BEEN HERE AN *HOUR,* AND ALREADY I'M MAKING FRIENDS.

IT'S THAT KIND OF *PLACE.*

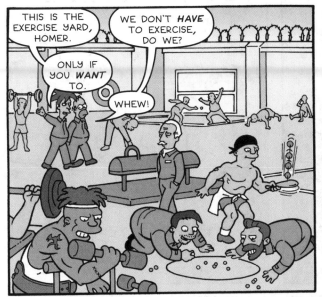

THIS IS THE EXERCISE YARD, HOMER.

WE DON'T *HAVE* TO EXERCISE, DO WE?

ONLY IF YOU *WANT* TO.

WHEW!

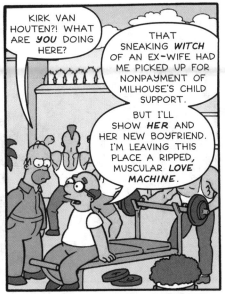

KIRK VAN HOUTEN?! WHAT ARE *YOU* DOING HERE?

THAT SNEAKING *WITCH* OF AN EX-WIFE HAD ME PICKED UP FOR NONPAYMENT OF MILHOUSE'S CHILD SUPPORT.

BUT I'LL SHOW *HER* AND HER NEW BOYFRIEND. I'M LEAVING THIS PLACE A RIPPED, MUSCULAR *LOVE MACHINE*.

SEE YOU AROUND THE YARD.

STACK ME *UP,* HOMES!

I'M PUMPIN' *RESENTMENT!*

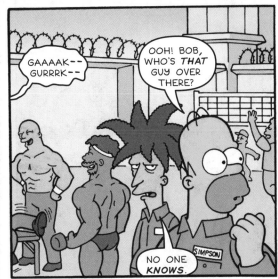

GAAAAK-- GURRRK--

OOH! BOB, WHO'S *THAT* GUY OVER THERE?

NO ONE *KNOWS.*

SIMPSON

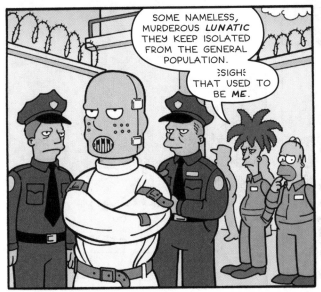

SOME NAMELESS, MURDEROUS *LUNATIC* THEY KEEP ISOLATED FROM THE GENERAL POPULATION.

:SIGH: THAT USED TO BE *ME*.

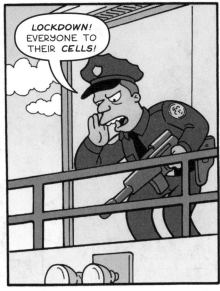

LOCKDOWN! EVERYONE TO THEIR *CELLS!*

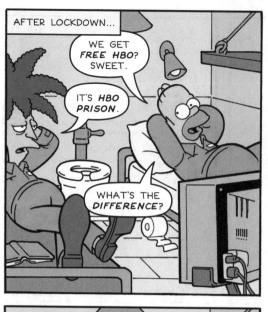

AFTER LOCKDOWN...

WE GET *FREE HBO?* SWEET.

IT'S *HBO PRISON.*

WHAT'S THE *DIFFERENCE?*

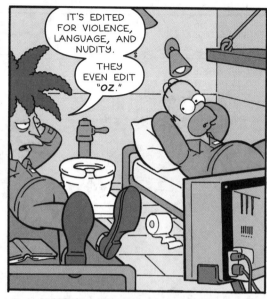

IT'S EDITED FOR VIOLENCE, LANGUAGE, AND NUDITY.

THEY EVEN EDIT *"OZ."*

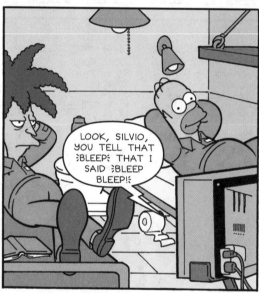

LOOK, SILVIO, YOU TELL THAT ⌐BLEEP⌐ THAT I SAID ⌐BLEEP BLEEP!⌐

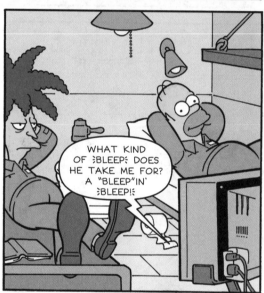

WHAT KIND OF ⌐BLEEP⌐ DOES HE TAKE ME FOR? A "BLEEP"IN' ⌐BLEEP!⌐

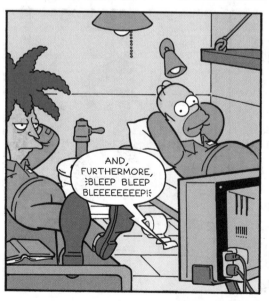

AND, FURTHERMORE, ⌐BLEEP BLEEP BLEEEEEEEEP!⌐

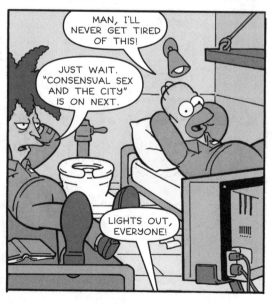

MAN, I'LL NEVER GET TIRED OF THIS!

JUST WAIT. "CONSENSUAL SEX AND THE CITY" IS ON NEXT.

LIGHTS OUT, EVERYONE!

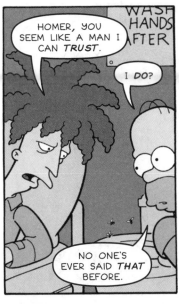

HOMER, YOU SEEM LIKE A MAN I CAN *TRUST*.

I *DO?*

NO ONE'S EVER SAID *THAT* BEFORE.

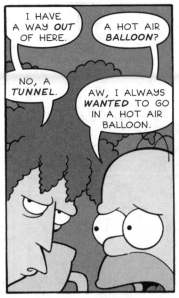

I HAVE A WAY *OUT* OF HERE.

A HOT AIR *BALLOON?*

NO, A *TUNNEL*.

AW, I ALWAYS *WANTED* TO GO IN A HOT AIR BALLOON.

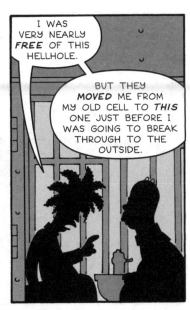

I WAS VERY NEARLY *FREE* OF THIS HELLHOLE.

BUT THEY *MOVED* ME FROM MY OLD CELL TO *THIS* ONE JUST BEFORE I WAS GOING TO BREAK THROUGH TO THE OUTSIDE.

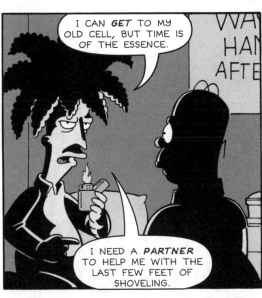

I CAN *GET* TO MY OLD CELL, BUT TIME IS OF THE ESSENCE.

I NEED A *PARTNER* TO HELP ME WITH THE LAST FEW FEET OF SHOVELING.

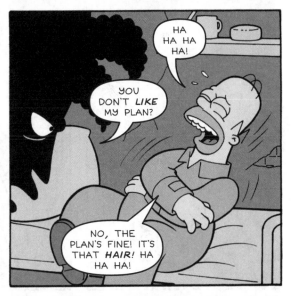

HA HA HA HA!

YOU DON'T *LIKE* MY PLAN?

NO, THE PLAN'S FINE! IT'S THAT *HAIR!* HA HA HA!

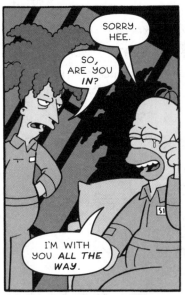

SORRY. HEE.

SO, ARE YOU *IN?*

I'M WITH YOU *ALL THE WAY*.

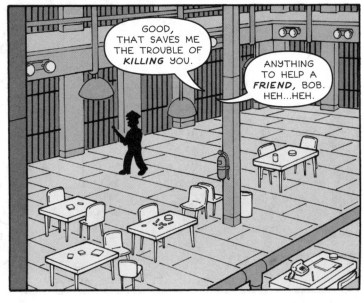

GOOD, THAT SAVES ME THE TROUBLE OF *KILLING* YOU.

ANYTHING TO HELP A *FRIEND*, BOB. HEH...HEH.

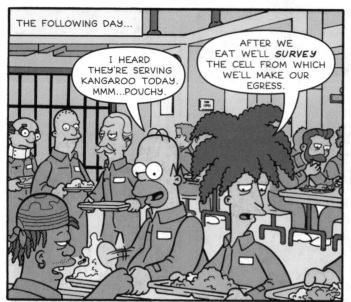

THE FOLLOWING DAY...

I HEARD THEY'RE SERVING KANGAROO TODAY. MMM...POUCHY.

AFTER WE EAT WE'LL *SURVEY* THE CELL FROM WHICH WE'LL MAKE OUR EGRESS.

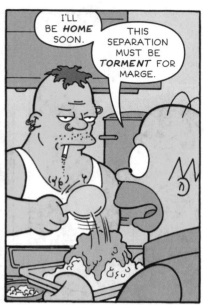

I'LL BE *HOME* SOON.

THIS SEPARATION MUST BE *TORMENT* FOR MARGE.

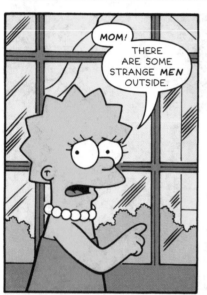

MOM! THERE ARE SOME STRANGE *MEN* OUTSIDE.

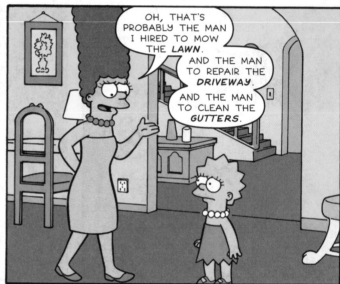

OH, THAT'S PROBABLY THE MAN I HIRED TO MOW THE *LAWN*.

AND THE MAN TO REPAIR THE *DRIVEWAY*.

AND THE MAN TO CLEAN THE *GUTTERS*.

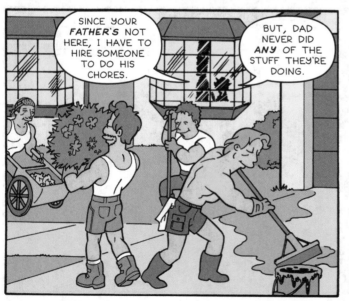

SINCE YOUR *FATHER'S* NOT HERE, I HAVE TO HIRE SOMEONE TO DO HIS CHORES.

BUT, DAD NEVER DID *ANY* OF THE STUFF THEY'RE DOING.

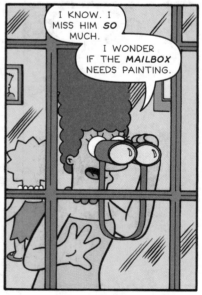

I KNOW. I MISS HIM *SO* MUCH.

I WONDER IF THE *MAILBOX* NEEDS PAINTING.

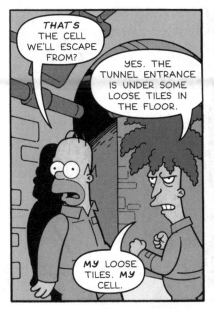

THAT'S THE CELL WE'LL ESCAPE FROM?

YES. THE TUNNEL ENTRANCE IS UNDER SOME LOOSE TILES IN THE FLOOR.

MY LOOSE TILES. MY CELL.

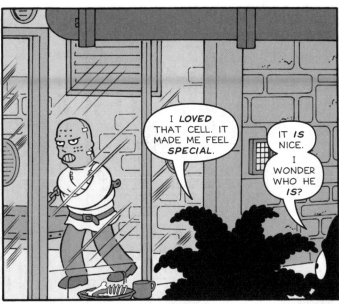

I LOVED THAT CELL. IT MADE ME FEEL SPECIAL.

IT IS NICE. I WONDER WHO HE IS?

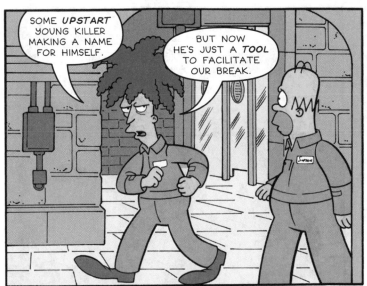

SOME UPSTART YOUNG KILLER MAKING A NAME FOR HIMSELF.

BUT NOW HE'S JUST A TOOL TO FACILITATE OUR BREAK.

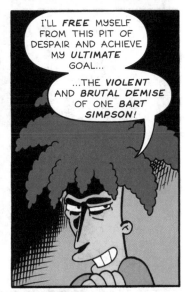

I'LL FREE MYSELF FROM THIS PIT OF DESPAIR AND ACHIEVE MY ULTIMATE GOAL...

...THE VIOLENT AND BRUTAL DEMISE OF ONE BART SIMPSON!

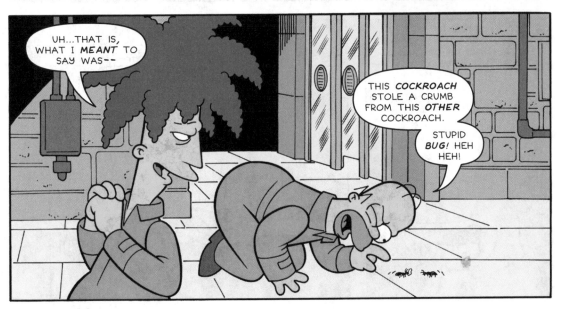

UH...THAT IS, WHAT I MEANT TO SAY WAS--

THIS COCKROACH STOLE A CRUMB FROM THIS OTHER COCKROACH.

STUPID BUG! HEH HEH!

THAT NIGHT...

"LIGHTS OUT! LIGHTS OUT!"

SPRINGFIEL
PENITENTIAR

IT'S *TIME*.

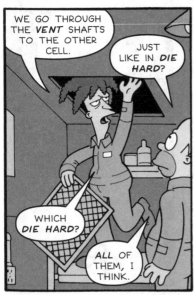

WE GO THROUGH THE *VENT* SHAFTS TO THE OTHER CELL.

JUST LIKE IN *DIE HARD*?

WHICH *DIE HARD*?

ALL OF THEM, I THINK.

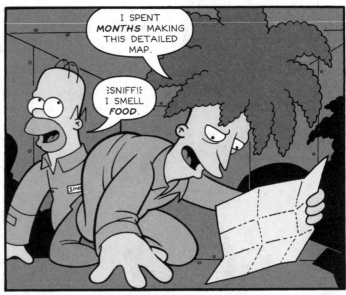

I SPENT *MONTHS* MAKING THIS DETAILED MAP.

⟨SNIFF!⟩ I SMELL *FOOD*.

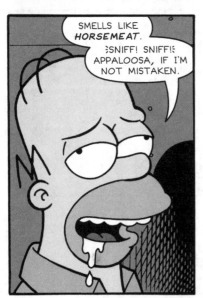

SMELLS LIKE *HORSEMEAT*. ⟨SNIFF! SNIFF!⟩ APPALOOSA, IF I'M NOT MISTAKEN.

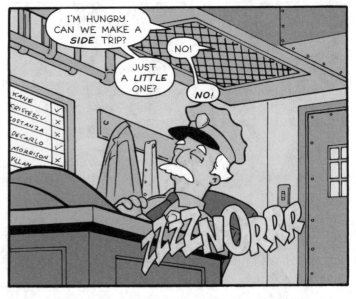

I'M HUNGRY. CAN WE MAKE A *SIDE* TRIP?

NO!

JUST A *LITTLE* ONE?

NO!

ZZZZNORRR

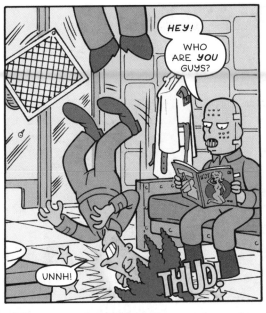

HEY! WHO ARE **YOU** GUYS?

UNNH!

THUD!

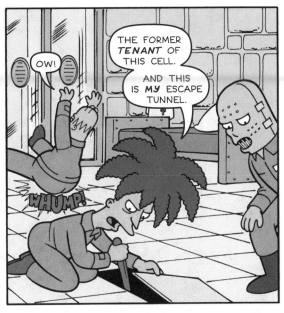

OW!

THE FORMER **TENANT** OF THIS CELL.

AND THIS IS **MY** ESCAPE TUNNEL.

WHUMP!

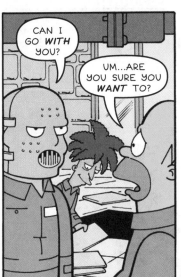

CAN I GO **WITH** YOU?

UM...ARE YOU SURE YOU **WANT** TO?

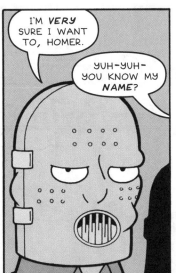

I'M **VERY** SURE I WANT TO, HOMER.

YUH-YUH-YOU KNOW MY **NAME?**

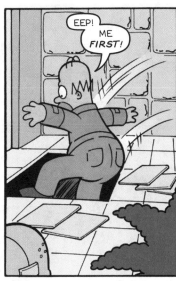

EEP! ME **FIRST!**

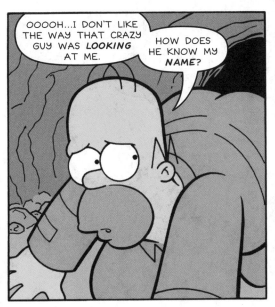

OOOOH...I DON'T LIKE THE WAY THAT CRAZY GUY WAS **LOOKING** AT ME.

HOW DOES HE KNOW MY **NAME?**

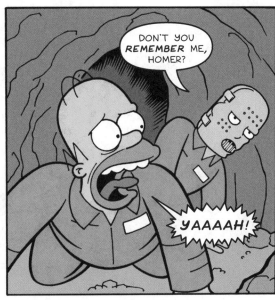

DON'T YOU **REMEMBER** ME, HOMER?

YAAAAH!

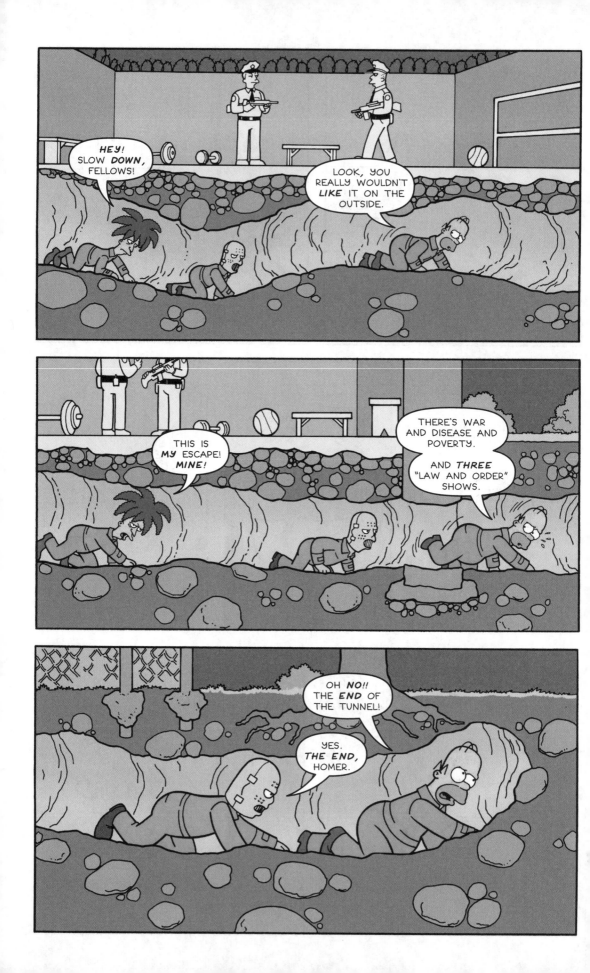

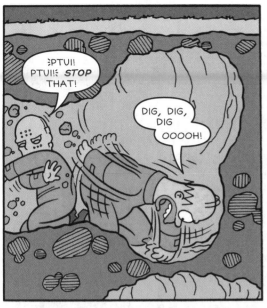

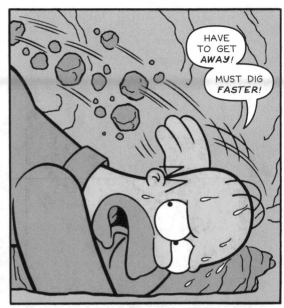

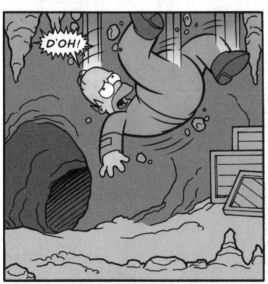

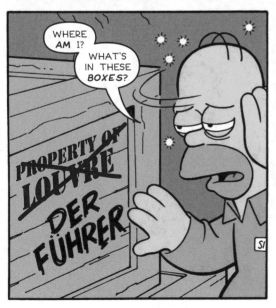

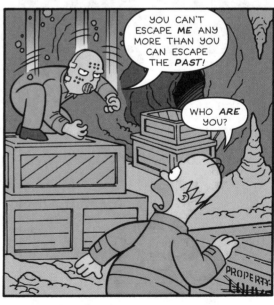

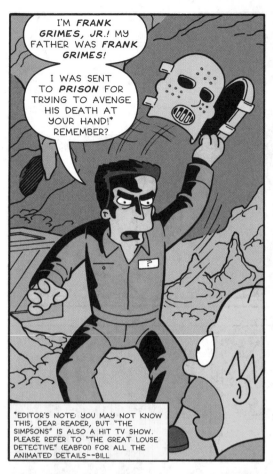

*EDITOR'S NOTE: YOU MAY NOT KNOW THIS, DEAR READER, BUT "THE SIMPSONS" IS ALSO A HIT TV SHOW. PLEASE REFER TO "THE GREAT LOUSE DETECTIVE" (EABF01) FOR ALL THE ANIMATED DETAILS--BILL

MR BURNS!

TWO *MISCREANTS* IN MY SECRET TREASURE VAULT!

YOU SET OFF *ALARMS* ALL OVER THE MANSION!

IT'S *HOMER SIMPSON*, SIR!

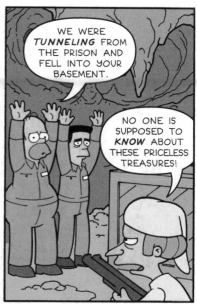

WE WERE *TUNNELING* FROM THE PRISON AND FELL INTO YOUR BASEMENT.

NO ONE IS SUPPOSED TO *KNOW* ABOUT THESE PRICELESS TREASURES!

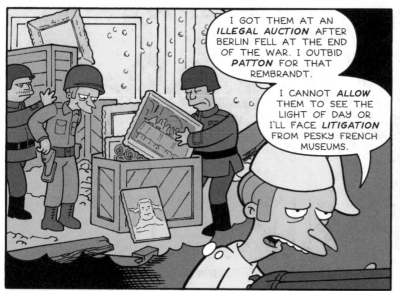

I GOT THEM AT AN *ILLEGAL AUCTION* AFTER BERLIN FELL AT THE END OF THE WAR. I OUTBID *PATTON* FOR THAT REMBRANDT.

I CANNOT *ALLOW* THEM TO SEE THE LIGHT OF DAY OR I'LL FACE *LITIGATION* FROM PESKY FRENCH MUSEUMS.

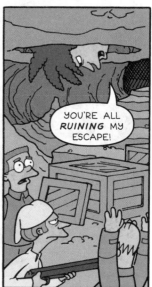

YOU'RE ALL *RUINING* MY ESCAPE!

CRUMBLE!

OH DEAR.

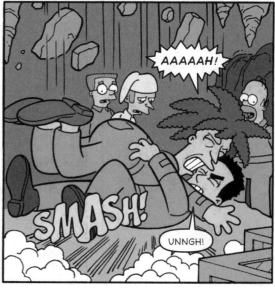

AAAAAH!

SMASH!

UNNGH!

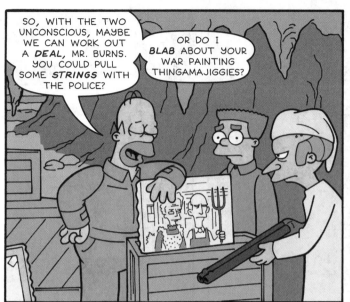

SO, WITH THE TWO UNCONSCIOUS, MAYBE WE CAN WORK OUT A *DEAL*, MR. BURNS. YOU COULD PULL SOME *STRINGS* WITH THE POLICE?

OR DO I *BLAB* ABOUT YOUR WAR PAINTING THINGAMAJIGGIES?

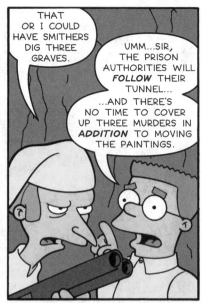

THAT OR I COULD HAVE SMITHERS DIG THREE GRAVES.

UMM...SIR, THE PRISON AUTHORITIES WILL *FOLLOW* THEIR TUNNEL...

...AND THERE'S NO TIME TO COVER UP THREE MURDERS IN *ADDITION* TO MOVING THE PAINTINGS.

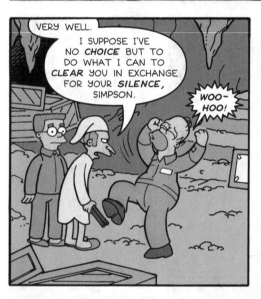

VERY WELL.

I SUPPOSE I'VE NO *CHOICE* BUT TO DO WHAT I CAN TO *CLEAR* YOU IN EXCHANGE FOR YOUR *SILENCE*, SIMPSON.

WOO-HOO!

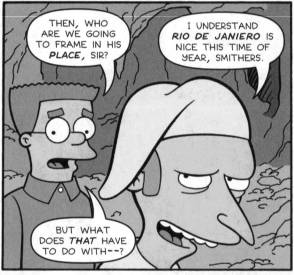

THEN, WHO ARE WE GOING TO FRAME IN HIS *PLACE*, SIR?

I UNDERSTAND *RIO DE JANIERO* IS NICE THIS TIME OF YEAR, SMITHERS.

BUT WHAT DOES *THAT* HAVE TO DO WITH--?

OH.

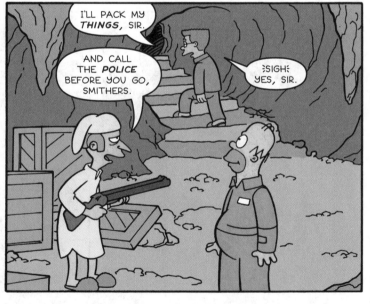

I'LL PACK MY *THINGS*, SIR.

AND CALL THE *POLICE* BEFORE YOU GO, SMITHERS.

:SIGH: YES, SIR.

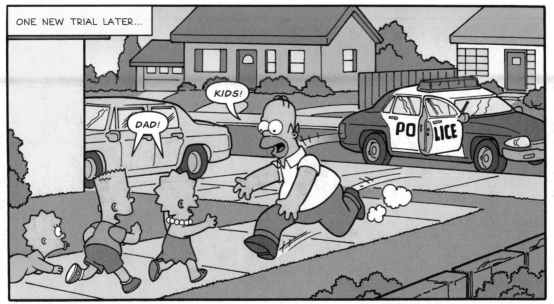

ONE NEW TRIAL LATER...

KIDS!

DAD!

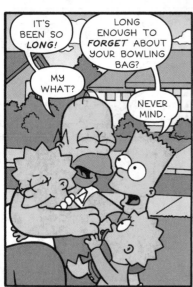

IT'S BEEN SO *LONG!*

LONG ENOUGH TO *FORGET* ABOUT YOUR BOWLING BAG?

MY WHAT?

NEVER MIND.

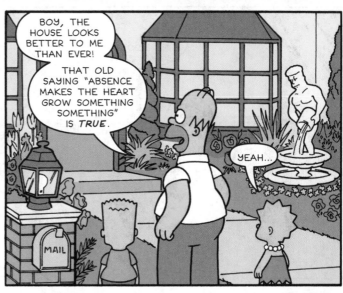

BOY, THE HOUSE LOOKS BETTER TO ME THAN EVER!

THAT OLD SAYING "ABSENCE MAKES THE HEART GROW SOMETHING SOMETHING" IS *TRUE*.

YEAH...

MAIL

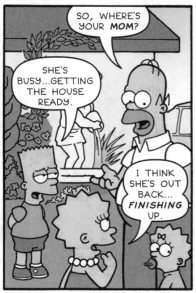

SO, WHERE'S YOUR *MOM?*

SHE'S BUSY...GETTING THE HOUSE READY.

I THINK SHE'S OUT BACK... *FINISHING* UP.

WELL, MANUEL, TRENT, BARRY... MY HUSBAND IS BACK. THIS IS *GOODBYE*.

⸢SIGH⸣ BUT WE'LL *ALWAYS* HAVE SPRING CLEANING.

THE END

CHUCK DIXON
SCRIPT

JOHN COSTANZA
PENCILS

MIKE DECARLO
INKS

ART VILLANUEVA
COLOR

KAREN BATES
LETTERS

BILL MORRISON
EDITOR

BART SIMPSON'S REPORT ON FRANCIS SCOTT KEY

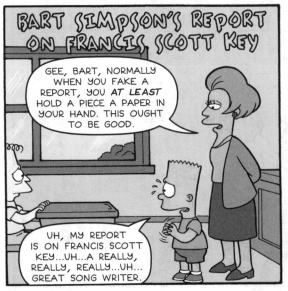

GEE, BART, NORMALLY WHEN YOU FAKE A REPORT, YOU *AT LEAST* HOLD A PIECE A PAPER IN YOUR HAND. THIS OUGHT TO BE GOOD.

UH, MY REPORT IS ON FRANCIS SCOTT KEY...UH...A REALLY, REALLY, REALLY...UH... GREAT SONG WRITER.

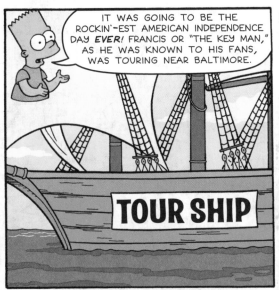

IT WAS GOING TO BE THE ROCKIN'-EST AMERICAN INDEPENDENCE DAY *EVER!* FRANCIS OR "THE KEY MAN," AS HE WAS KNOWN TO HIS FANS, WAS TOURING NEAR BALTIMORE.

TOUR SHIP

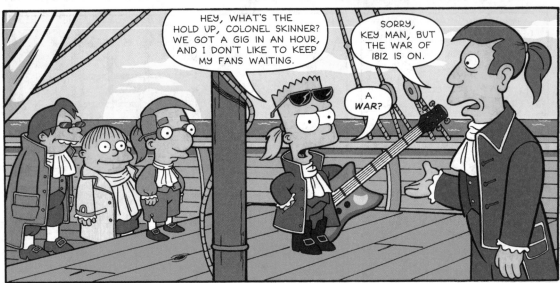

HEY, WHAT'S THE HOLD UP, COLONEL SKINNER? WE GOT A GIG IN AN HOUR, AND I DON'T LIKE TO KEEP MY FANS WAITING.

SORRY, KEY MAN, BUT THE WAR OF 1812 IS ON.

A WAR?

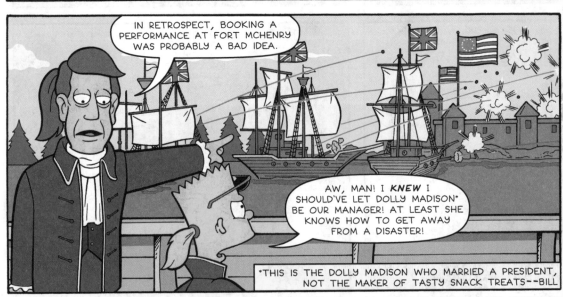

IN RETROSPECT, BOOKING A PERFORMANCE AT FORT MCHENRY WAS PROBABLY A BAD IDEA.

AW, MAN! I *KNEW* I SHOULD'VE LET DOLLY MADISON* BE OUR MANAGER! AT LEAST SHE KNOWS HOW TO GET AWAY FROM A DISASTER!

**THIS IS THE DOLLY MADISON WHO MARRIED A PRESIDENT, NOT THE MAKER OF TASTY SNACK TREATS--BILL*

TONY DIGEROLAMO SCRIPT **PHIL ORTIZ** PENCILS **MIKE DECARLO** INKS **ROBERT STANLEY** COLORS **KAREN BATES** LETTERS **BILL MORRISON** EDITOR